IDLE HOURS

AMERICANS AT LEISURE 1865–1914

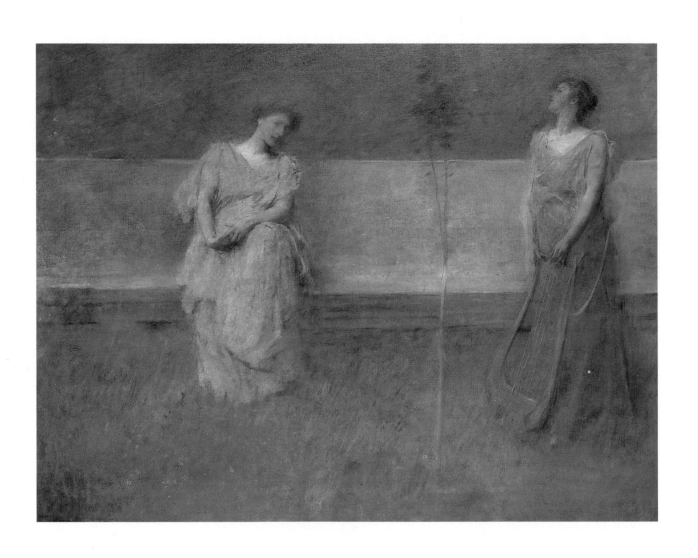

IDLE HOURS

AMERICANS AT LEISURE 1865–1914

by RONALD G. PISANO

designed by JOHN ESTEN

A New York Graphic Society Book
Little, Brown and Company
Boston Toronto London

Frontispiece: Thomas Dewing, THE SONG, 1891
oil on canvas, 26 × 34 inches, Private Collection.

———————————

FIRST EDITION

Library of Congress Cataloging-in-Publication Data
Pisano, Ronald G.
Idle hours.
"A New York Graphic Society book."
Bibliography: p.
Includes index.
1. Painting, American. 2. Leisure class in art.
3. Painting, Modern — 19th century — United States.
4. Painting, Modern — 20th century — United States.
I. Title.
ND1460.L45P57 1988 758′.930648′0973 88-8879
ISBN 0-8212-1673-2

NEW YORK GRAPHIC SOCIETY BOOKS
ARE PUBLISHED BY
LITTLE, BROWN AND COMPANY (INC.)

Published simultaneously in Canada
by Little, Brown & Company (Canada) Limited

PRINTED IN JAPAN

Contents

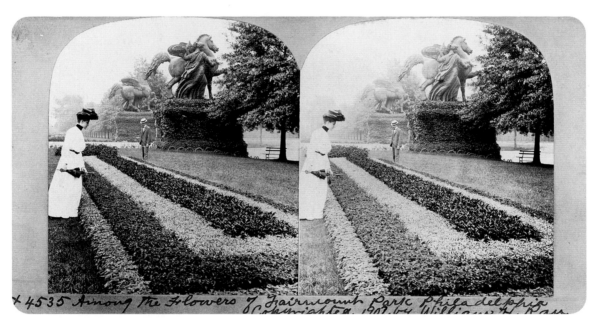

William H. Rau, AMONG THE FLOWERS OF FAIRMOUNT PARK, PHILADELPHIA, 1902
Library of Congress.

Preface

The years between the close of the Civil War and the outbreak of World War I were a time of great prosperity for some Americans. Referred to as the "picnic generation," the ever-growing privileged class found increasing time for leisure pursuits — some physical, such as boating, bicycling, or playing golf; others more intellectual, such as reading, playing chess, or attending musicals. Some people just "idled" away their time, swinging in hammocks or lounging by the seaside. Artists of the period depicted the rise of this new breed of American, who was no longer the pioneer of the frontier but an urban cosmopolite — genteel, refined, and sophisticated. The image (and the attitude associated with it) appeared in paintings, in illustrations, and eventually in photographs, all capturing the spirit of the era, a gilded age in America's development. That spirit was best captured by fashionable American painters who worked both at home and abroad, portraying the carefree lives of their countrymen during their leisure hours.

Whether depicting a scene in the Luxembourg Gardens in Paris or one in New York's Central Park, these painters provided a very personal and specific view of one sector of American society at the turn of the century. The image they created was intended to appeal to the very type of people they portrayed. Their true inspiration, however, came from their pride in American art and its growing importance in the eyes of the Western world — as indicated by the many prizes and awards garnered by American artists at the Paris Salon and other significant international exhibitions. They were also proud of their own success, and most led lives similar to those of the genteel people they painted. The titles these artists chose for their paintings reflect the moods and attitudes they felt best typified the lives of the upper classes: *Contentment, Reverie, Solitude, Harmony,* and, of course, *Idle Moments, Idle Hours,* and *Two Idlers.* Although the word *idle* had a negative connotation in early-nineteenth-century America and to some extent has one today, at the turn of the century having idle time connoted prosperity and represented a mark of distinction for those wealthy enough to indulge in nonproductive pursuits of pleasure.

William Merritt Chase, IDLE HOURS, ca. 1894
oil on canvas, 25½ × 35½ inches, Amon Carter Museum, Fort Worth, Texas.

Introduction

In the mid–nineteenth century, Americans continued to be shackled to their puritanical heritage and remained relatively isolated from cultural developments abroad. Labor, whether necessary or not, was considered a prime virtue among patriotic Americans, whereas leisure was deemed a vice. Nowhere was this more plainly manifested than in church sermons given in rural areas, as evidenced in one delivered by a worthy pastor in 1839: "A man of leisure is one who has nothing to do — a condition supposed to be honorable in those countries where false forms of society make the many the servants of the few; but happily not in our own, where the greatest good to the whole number is the glorious aim of an intelligent democracy. Here the laborer is honorable, the idler infamous. We tolerate no drones in our hive. Sweat drops on the brow of honest toil are more precious than the jewels of a ducal coronet. We have no leisure, for the truly virtuous and faithful will find occupation for every moment."[1] Although this preacher's language was undoubtedly exaggerated for effect, his point would have been clear to, and approved of by, his congregation. This spirit abounded throughout democratic America and was reflected in the scenes represented by early landscape and genre painters. Their themes were intended to be spiritually uplifting, inspirational, and noble, and though some paintings of the period were meant to be amusing, the humor in these works was almost always intended to convey a moral lesson. The style of these paintings was straightforward, detailed, and realistic, enabling their message to be understood by all. The artists portrayed an agrarian America, focusing almost exclusively on rustic scenes and activities.

By the end of the Civil War, however, such virtuous ideals had become tarnished, and such visions seemed nostalgic. In the ensuing decade new social standards were adopted by a rapidly growing urban population that was dominated by a group of prosperous individuals — the leisure class. Unlike their forefathers, who had condemned idleness, this social class valued leisure as a respectable sign of success. Thorstein Veblen, in his major sociological study of the period, *The Theory of the Leisure Class,* described and analyzed this emerging class and established a means of categorizing and explaining its behavior. In short, "leisure," as defined by Veblen, was the "chief mark of gentility." Elaborating further, he explained that his use of the word *leisure* did not imply "indolence or quiescence"; "What it connotes is non-productive consumption of time. Time is consumed non-productively (1) from a sense of the unworthiness of productive work, and (2) as evidence of pecuniary ability to afford a life of idleness." He defined the leisure class as the "propertied, non-industrial" class, whose main purpose in society was that of "acquisition, not of production; of exploitation, not of serviceability." Veblen went on to explain the relationship between social status and the possession of "conspicuous leisure time": as more and more Americans shared in the prosperity of the gilded age by having more leisure time, the social status of the leisure class shifted its emphasis from "conspicuous leisure" to "conspicuous consumption." If having free time was no longer a mark of distinction, having and spending money was.[2]

As one desperate member of the prosperous middle class complained, "Our opulent friends are constantly demonstrating to us by example how indispensably convenient the modern necessaries are, and we keep having them until we either exceed our incomes, or miss the higher concerns of life in the effort to maintain a complete outfit of its creature comforts." The same gentleman lamented, "And the saddest part of it all is that it is in such great measure an American development."[3]

Popular magazines of the day debated the issue of whether or not it was proper for Americans to indulge in leisure activities. Some held steadfastly to this country's puritanical past: "The American sentiment that everyone ought to have something to do, is a sound sentiment," maintained one writer.[4] Another concurred, saying, "Work is good," and then stipulated, "but work is not the only good thing in the world . . . the god of labor does not abide exclusively in the rolling-mill, the law courts, or the cornfield. He has a twin-sister whose name is leisure, and in her society he lingers now and then to the lasting

gain of both." The same writer suggested that leisure should be cultivated, used, and enjoyed, and proclaimed that it is from leisure that man "constructs the true fabric of self."[5]

Having covered the spectrum of written opinion, we are advised by still another writer of the period that future social historians should not put much trust in the essays, newspapers, sermons, and other reports that Americans were an "overworked race, incapable of amusing ourselves." As proof of this, he enumerated the various leisure activities that were particularly popular in his day: rowing, fishing, driving, bathing, mountain climbing, boat racing, lawn tennis, baseball, and "mooning on the piazza," as well as indoor games.[6] Somewhat more esoteric and less invigorating were the "conventional accomplishments of the leisure class" outlined by Veblen — "knowledge of the dead languages and the occult sciences; of correct spelling; of syntax and prosody; of the various forms of domestic music and of the household art; of the latest proprieties of dress, furniture, and equipage."[7]

All but the wealthiest leisure-class men worked; therefore women and children had the most leisure time. According to genteel standards, a woman's domain was her home; her obligations beyond that were social ones, and little else. Some writers of the period actually believed that women were physically incapable of even the simplest types of employment, such as working as clerks in dry-goods stores. One critic righteously stated, "Any woman who consents to become a mother has no moral right to engage in any employment which will unfit her for that function."[8] In fact, a leisure-class woman's duties were probably more taxing than those of a dry-goods clerk. A refined woman was expected to oversee the household, supervise servants, raise children, pursue some form of decorative art, entertain, make social calls, and engage in charity work.

Not surprisingly, some women found juggling all of these activities overwhelming, and that difficulty became a humorous topic to be bantered about in the popular press. One respectable lady facetiously complained: "My idea of a model nursery . . . is a padded room, with barred windows, and everything in it, when not in use, hung out of reach upon the walls. Then one might sit down-stairs in the drawing-room and read, or practice, or receive, with a mind at rest."[9] Some critics asserted that society women did indeed neglect their children, turning them over to nurses who were known to be wicked and cruel; one writer of the day, however, reassured us: "The aver-

J. Byron, THE LIVINGSTON CRICKET CLUB, STATEN ISLAND, 1893
The Byron Collection, Museum of the City of New York.

age American mother, in society or out, is a good mother. . . . She is not apt to get tipsy and set the baby on the stove; nor yet to neglect it . . . for the sake of 'gyrating in a ball-room, or posing at the opera and having a perfectly lovely time.' " The same writer claimed: "A 'society woman' may spend eight hours daily in intimate association with her children, and still have eight hours in which to 'gyrate and pose,' to dine and to pay visits, and even at a pinch to take a hand in more than one good work." [10] Obviously leisure time for a society woman did not mean "idle time."

The rise of the leisure class in America coincided with the development of the aesthetic movement, and neither would have been possible without the growing prosperity and improved technology of the gilded age. The first meaningful display of major technological advances was the Centennial Exposition, held in Philadelphia in 1876. At this international fair Americans saw such modern-day wonders as the typewriter, Bell's telephone, Edison's multiplex telegraph, and the powerful Corliss Steam Engine. Also on view was the first comprehensive exhibition of Japanese art, and an international group of paintings and decorative arts. Although America made an impressive technological showing, many felt that our cultural display was inferior, particularly in the decorative arts. This reaction prompted Candace Wheeler and several other genteel women to form the Society of Decorative Art in New York in 1877. The Society held regularly scheduled exhibitions and offered considerable cash awards annually for the best designs submitted for portieres, window-hangings, screens, table covers, and similar decorative endeavors. More than three thousand dollars in prizes were offered in 1881, with a top award of five hundred dollars. [11] The Society of Decorative Art and other organizations like it influenced leisure-class life in America in several important ways: they served to improve the standards of decorative arts, to promote a better understanding and appreciation of them, to heighten the awareness of interior design in the leisure-class home, and to provide the genteel woman with not only a creative outlet but a means of supplementing her income in an acceptable way.

With the impact of the Centennial Exposition and subsequent artistic and technical developments, America became a modern nation, and its art reflected that. The most progressive of its artists were those trained in the art centers of Europe — London, Munich, and Paris being the most popular. When these artists returned to America in the 1870s, they challenged the complacency of the old guard — the painters of the Hudson River School and their colleagues who showed at the National Academy of Design in New York. The new group founded their own organization, the Society of American Artists. The paintings they exhibited in their annual shows differed from the older artists' works both in subject and in style, stressing figure-painting rather than landscape and following the dictum of "art for art's sake" championed by James McNeill Whistler and other advanced artists. No longer was there a message to be conveyed, a moral statement to be made — these paintings, like the art objects introduced with the aesthetic movement, were meant to be enjoyed for their beauty alone. The inspiration for many of these paintings was drawn from the past, from ancient Greece, Renaissance Italy, Medieval England, seventeenth-century Holland and Spain — almost any European culture, as well as major Eastern civilizations, such as Japan, China, and India. Kenyon Cox, a proponent of this eclectic style of painting, explained, "Each new work [should] connect itself in the mind of him who sees it with all the noble and lovely works of the past. . . . It wishes to add link by link to the chain of tradition." [12] Some — Cox included — became shackled by this chain, laboriously creating lifeless, saccharine images that displayed only the most superficial traits of great civilizations of the past, with no meaningful relationship to the modern-day world.

Others, however, were galvanized by the vitality of such great artists of the past as Hals, Velasquez, and the Dutch masters, and took their works as inspiration for capturing the confident spirit of modern life in America. These American artists looked only at the positive side of life, creating an image of cheerfulness, optimism, and high spirits. Many of them actually lived such lives and used their own family and friends as models for their paintings. What they captured and preserved in these paintings was admittedly not a comprehensive view of life in this country, or even the norm. They focused, instead, almost exclusively on the life of the members of the privileged class, who served as their subjects as well as their patrons. They painted portraits of successful businessmen, posed formally or taking part in sporting activities. Their specialty, however, was painting genteel women engaged in domestic pursuits — reading, sewing, playing parlor games, or merely lounging — and children, who were charmingly carefree. The settings they chose were usually domestic ones, illustrating the comfortable life of the leisure class. Their style of painting was lyrical, harmonious, and clearly an expression of art for

art's sake. Sometimes their work was tonal and intimate, reflecting the influence of seventeeth-century Dutch artists such as Vermeer or more recent artists such as Whistler. The work they painted outdoors glistened with bright sunshine, recalling the techniques of the French Impressionists. In either case the mood was always tranquil.

The climax of this era was the Columbian Exposition, held in Chicago in 1893. It was considered by many to be the greatest achievement in America to date, and every true member of the leisure class was expected to attend. The Exposition had a powerful and far-reaching impact, being the largest and most popular event of its kind in America. Visitors were awed by America's artistic and technological progress and left with great confidence in the future.

As America entered the twentieth century, the focus of its art began to change. Some painters of the leisure class continued to create carefree, languid visions of fashionable Americans at play, and a few managed to do so without becoming hackneyed. Many of their followers, however, were generally less well trained, churning out weak, thin, and boring images and providing only superficial views of the leisure class and its activities. One significant exception was George Bellows. Bellows's sporting scenes of the genteel set aptly capture the haughty elegance and self-confidence of the mature leisure class. These works, however, are unusual in Bellows's oeuvre, since he is better known for more urban themes and subjects. Along with Robert Henri, John Sloan, Everett Shinn, and others, Bellows was associated with a group referred to as the Ashcan School, which focused on a different segment of American society — immigrants and working-class people. These painters replaced the dictum of "art for art's sake" with a new philosophy, "art for life's sake." No longer was it important for a work of art to be beautiful; now it had to be real, and reality for these artists was not leisure-class parlors or verandas but the streets and tenements of the city. This approach to art was shocking to some and deplorable to others, most especially to those artists who had specialized in painting the complacent life of leisure-class America. In spite of this, Henri and his friends succeeded in gaining acceptance for their work, though their place at the vanguard of American painting was short-lived.

In 1915 the leisure-class painters had one last hurrah as they celebrated their achievements at the Panama-Pacific Exposition, held in San Francisco in 1915. William Merritt Chase, then sixty-four, and others were honored by having separate galleries for impressive displays of their work. Some of the best artists of this generation, however, died not long afterward — Chase in 1916, James Carroll Beckwith in 1917, and Julius Stewart in 1920. Many others had died some years before, including James McNeill Whistler and Robert Blum in 1903 and Winslow Homer in 1910. Some artists, including Irving Wiles and the Boston painters Frank Benson and Edmund Tarbell, among others, successfully carried on the tradition of leisure-class painting for a while longer, but for the most part the movement had ended along with the gilded age that had brought it into being. The word *idle* regained the negative connotation it had had in the early nineteenth century. No longer a mark of social stature, as in the titles of paintings by artists in turn-of-the-century America — Chase's *Idle Hours* and Blum's *Two Idlers,* for example — the term reverted to its earlier meanings, "fruitless" and "bootless," as devastating wars and a severe depression took their toll on America's optimistic vision and ideal life.

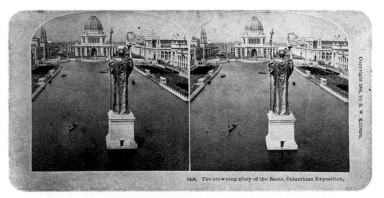

B. W. Kilburn, CROWNING GLORY OF THE BASIN, COLUMBIAN EXPOSITION, 1893
Robert Dennis Collection of Stereoscopic Views. Photograph Collection,
Miriam and Ira D. Wallach Division of Art Prints and Photographs,
The New York Public Library, Astor, Lenox and Tilden Foundations.

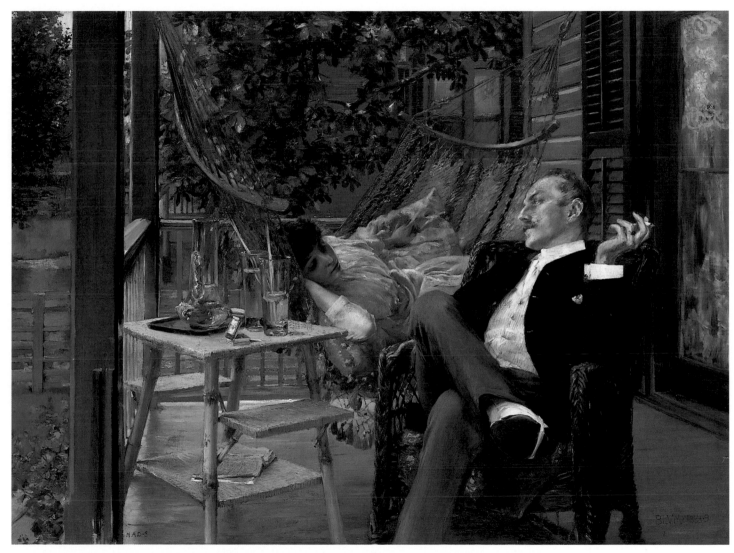

Robert Blum, TWO IDLERS, 1888–1889
oil on canvas, 29 × 40 inches, National Academy of Design New York.

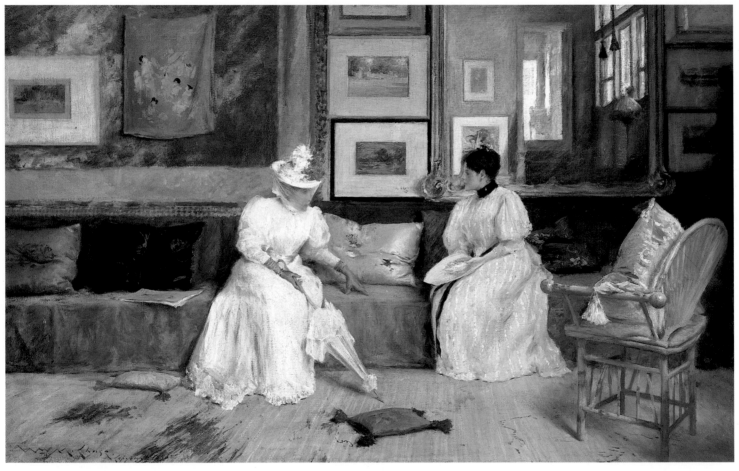

William Merritt Chase, A FRIENDLY CALL, 1895
oil on canvas, 30⅛ × 48¼ inches, National Gallery of Art, Washington, D.C., Chester Dale Collection.

Entistaining

Entertaining and paying social calls were of great importance to society during the gilded age; in fact, the latter became de rigueur — and to some, a burden. The setting for these receptions was generally the parlor, the dining room, or, for an artist, the studio. The studio could be a relatively modest one (albeit artistic and bohemian), as portrayed in H. Siddons Mowbray's *Studio Lunch.* Or it could be more elaborate and elegant, like William Merritt Chase's summer studio on eastern Long Island, which appears in his painting *A Friendly Call.* Mowbray's painting, done during the height of his student days in Paris, provides a typical view of a young artist's studio, with its decorative trappings, paintings, Oriental carpets, and the painter's own palette (hanging on the wall in the background). It is a fitting setting for the artist and his model to share their lunch without feeling any obligation to engage in conversation.

Chase's painting *A Friendly Call,* in contrast, shows a very different scene, in which there is no indication of the artist's occupation. The setting appears to be an elegant room in which the prosperous artist's genteel wife can receive callers. Two fashionably dressed leisure-class women (Mrs. Chase is on the right), rigidly posed, politely discuss some pertinent matter of the day or some domestic topic. In doing so, both are fulfilling their respective social obligations, calling and being received. As one social historian explains: "Calling — paying ritualized visits to friends — was the most important leisure activity for middle-class women in the post-centennial era. It was a complex and mannered procedure by which people identified their social intentions and maintained or sought to overcome class distinctions."[1]

The proper time to call was between three and five in the afternoon, and an elaborate system of handling calling cards was devised: when the upper right corner was folded, it meant one had come in person; upper left corner folded expressed congratulations, lower right corner

folded meant "goodbye," and lower left corner folded offered condolences. If the entire left end was folded, it meant one had come to visit all the women in the family, not just the mistress of the household. Although the hostess could choose not to see a visitor and, by ignoring a card given and/or a visit paid, could indicate that she chose not to strike up or maintain a social relationship, there was great social pressure to participate in such rituals.[2]

Some intellectual and professional women, like the art critic M. G. Van Rensselaer, objected to the wasteful nature of such protocol, which consumed time and effort that could be better used: "Is it not time that a protest should be made against the absurdity and unprofitableness of our custom of 'paying calls'?" she asked.[3]

Not only was it time-consuming to call and receive, it was even more tedious to learn what to say and how to say it. Mrs. John Sherwood, a contemporary arbiter of manners, declared that it was important for a young woman to "fortify herself with several topics of general interest, such as the last new novel, the last opera, the best and newest gallery of pictures, or the flower in fashion." Mrs. Sherwood also counseled that "at a mixed dinner . . . nothing should be said which can hurt any one's feelings — politics, religion, and the stock market being generally ruled out," as were discussions about "disappointments," "good deeds," health, and servants.[4]

Though not a fit topic for dinner conversation, servants, if one could afford them, were a necessity for an affluent houshold. As Thorstein Veblen explained, "Under a man-datory code of decency, the time and effort of members of such a household are required to be ostensibly all spent in a performance of conspicuous leisure, in the way of calls, drives, clubs, sewing circles, sports, charity organizations, and other social functions."[5] Someone had to remain behind to clean and care for all of the important symbols of social status, such as the silver, the imported linen, and the hand-painted china. When it came to the valuable and fragile china, however, the mistress of the house often assumed an active role, as depicted in Gari Melchers's *The China Closet*. In this painting, Mrs. George Hitchcock, the wife of a successful expatriate painter, is depicted delicately taking china from a cabinet and carefully placing it on a tray held by her maid, who timorously assists her.

By the turn of the century, the use of candles at social gatherings came into vogue. Thirty years earlier, when they were the cheapest form of lighting available, candles were considered to be vulgar. But with technological improvements, they became a less practical means of illumination and thus acquired a ceremonial purpose. As Thorstein Veblen pointed out, "candle-light is now softer, less distressing to well-bred eyes, than oil, gas or electric light."[6] The use of candles at a social function can be seen in Irving Wiles's *Russian Tea,* which portrays another form of fashionable entertainment for genteel women, who, gathered around a table set with fine crystal, china, and highly polished brass, are about to engage in decorous conversation over sips of imported tea.

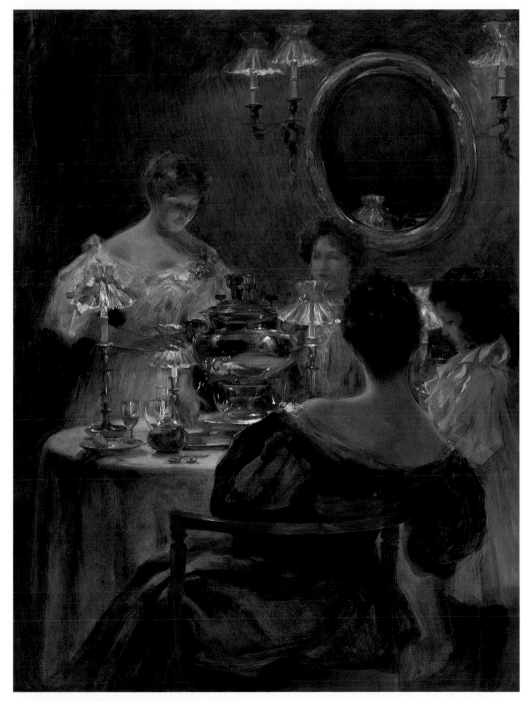

Irving Ramsay Wiles, RUSSIAN TEA, ca. 1896
oil on canvas, 48⅛ × 36⅛ inches, National Museum of American Art, Smithsonian Institution,
Gift of William T. Evans.

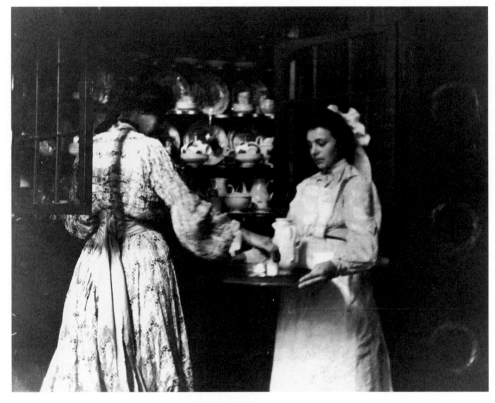

Gari Melchers, THE CHINA CLOSET MODELS, ca. 1900
Belmont, The Gari Melchers Memorial Gallery, Mary Washington College, Fredericksburg, Virginia.

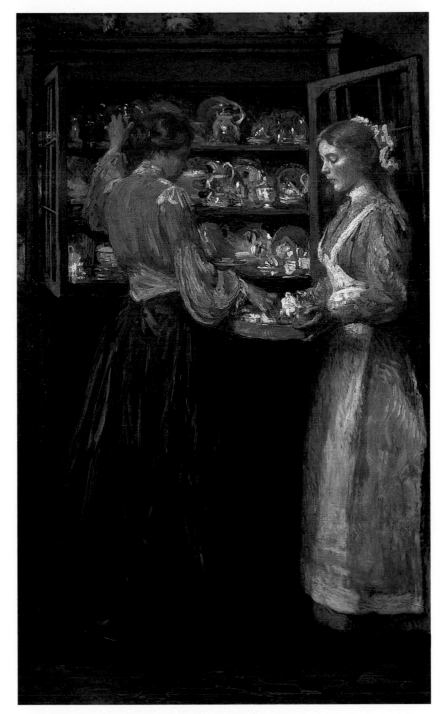

Gari Melchers, THE CHINA CLOSET, ca. 1900
oil on canvas, 50⅜ × 30⅜ inches, Belmont, The Gari Melchers Memorial Gallery,
Mary Washington College, Fredericksburg, Virginia.

James Carroll Beckwith, A MODEL'S BREAKFAST, ca. 1881
oil on canvas, 30 × 40 inches, Collection George R. Stroemple.

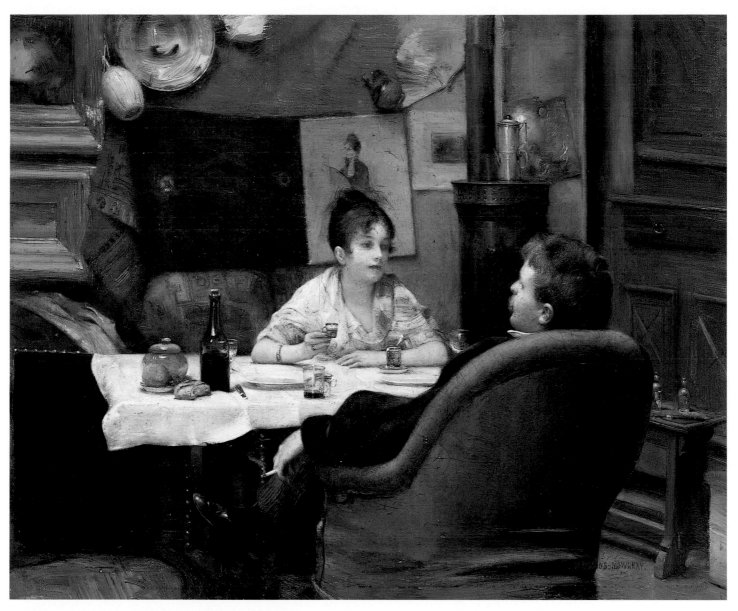

Henry Siddons Mowbray, STUDIO LUNCH, ca. 1880–1883
oil on canvas, 8⁵⁄₁₆ × 10⁷⁄₁₆ inches, Collection Jo Ann and Julian Ganz, Jr.

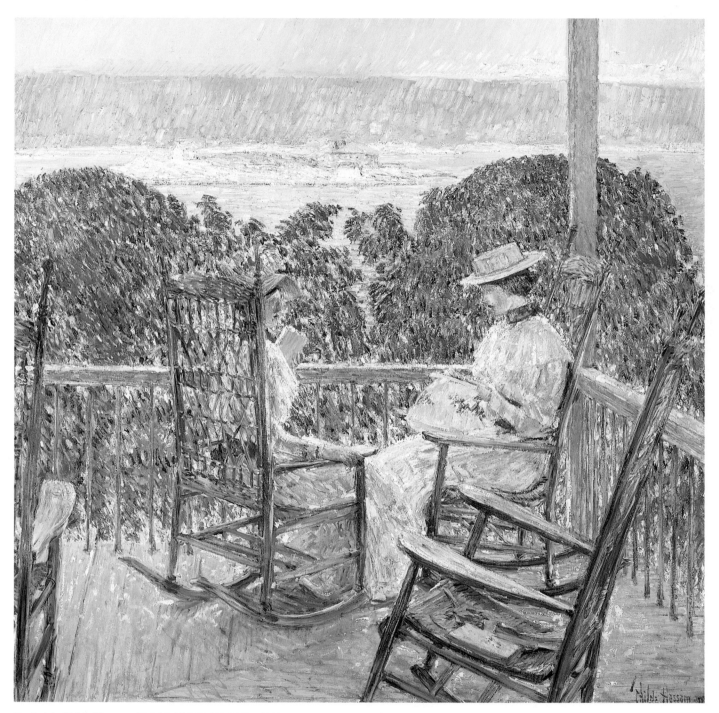

Frederick Childe Hassam, TEN POUND ISLAND, 1896
oil on canvas, 32¼ × 32¼ inches, Warner Collection of Gulf States Paper Corp., Tuscaloosa, Alabama.

Lounging Outdoors

During the summer months, the porch (also known as the piazza) replaced the parlor as the setting for leisure-class lounging and entertaining. In fact, an article devoted to this subject, titled "Outdoor Parlors," appeared in *Scribner's* in August 1881. The author, Ella Rodman Church, attributed the enthusiasm for this fad to "the girls, who know the value of a front piazza with a thick green curtain of honeysuckle and wisteria, making a shady retreat through the long June days, and the torrid August noons." The same writer pointed out the value of this setting for informal entertaining: "It is the most delightful, dreamy lounging place, [where] the steps are frequently occupied by half-visitors who could scarcely nerve themselves up to the formula of a regular call."[1] On a more romantic note, Church described the ambience the piazza provided on warm summer nights "when the moonlight comes out and traces a lattice-work of leaves on the piazza floor, and touches with lambent light each spray and corner." It was then, she proclaimed, that "the out-door parlor is in its glory."[2]

The casual nature of the piazza is illustrated in American paintings of the period. It was a place where women could gather and chat under the shade of the roof, as seen in Irving Wiles's *On the Veranda,* of 1887, or join in genteel activities such as embroidery and reading, as shown in Childe Hassam's *Ten Pound Island.* It also provided a suitable place for fashionable young women to simply strike relaxed poses while seated on a porch railing, as demonstrated in Robert Reid's *Summer Girl.* Furthermore, it was a charming and refreshing setting where genteel young women could entertain gentleman callers, as portrayed in Robert Blum's *Two Idlers.*

The proper furnishing for the piazza is best illustrated in Blum's painting, with its bamboo and rattan table, its wicker chair and decorative hammock. The hammock, used both on the piazza and in the garden, became one of the most popular outdoor accessories of the day. Its chief function was to serve the needs of genteel women — "lying ensconced in its lacy meshes idly listening to the hum of the busy bees at work."[3] Undoubtedly it was a comfortable spot for lounging; it also complemented a woman's graceful curves and the free-flowing lines of her gown, thus providing artists with appealing subject matter.

Outdoor lounging aside, informal entertaining often extended beyond the piazza to the garden, as seen in Edmund Tarbell's *Three Sisters — A Study in June Sunlight.* Such settings naturally appealed to Tarbell and other artists, who, under the influence of the French Impressionists, favored bright, sunlit scenes.

Peonies and lilacs were especially popular in garden settings, both for their beauty and for their fragrance. Childe Hassam surely realized that those who viewed his painting *Under the Lilacs* would recall the beautiful, heady fragrance associated with the lilac, as well as its intrinsic beauty. The pungent scent of the geranium is likewise evoked by Hassam's painting *Summer Evening,* in which a young woman idly touches the full-blown petals of this flower.

Whether on the piazza, in the garden, or by the window, sunlight, fresh air, and flora provided a natural and informal setting for American Impressionist painters of the period, who favored sunny settings and lovely and fashionable subjects for their cheerful paintings.

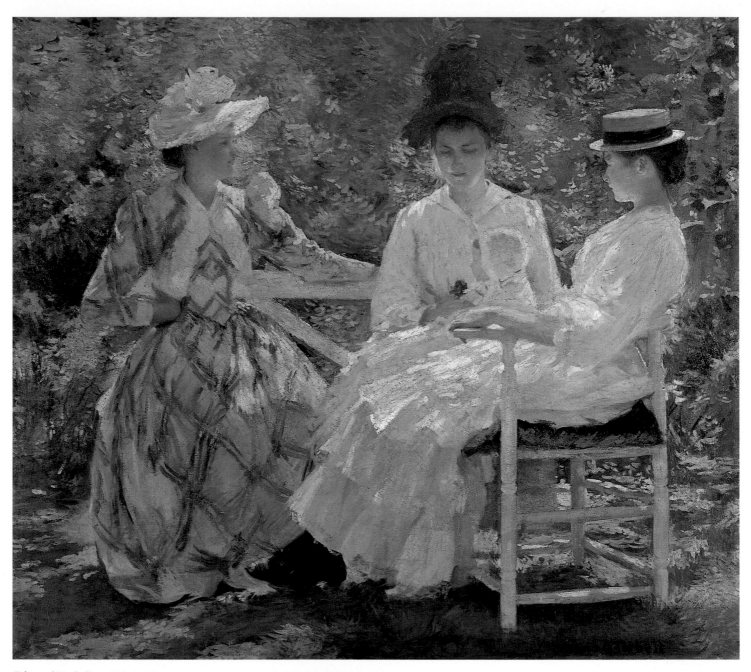

Edmund Tarbell, THREE SISTERS — A STUDY IN JUNE SUNLIGHT, 1890
oil on canvas, 35⅛ × 40⅛ inches, Milwaukee Art Museum, Gift of Mrs. Montgomery Sears.

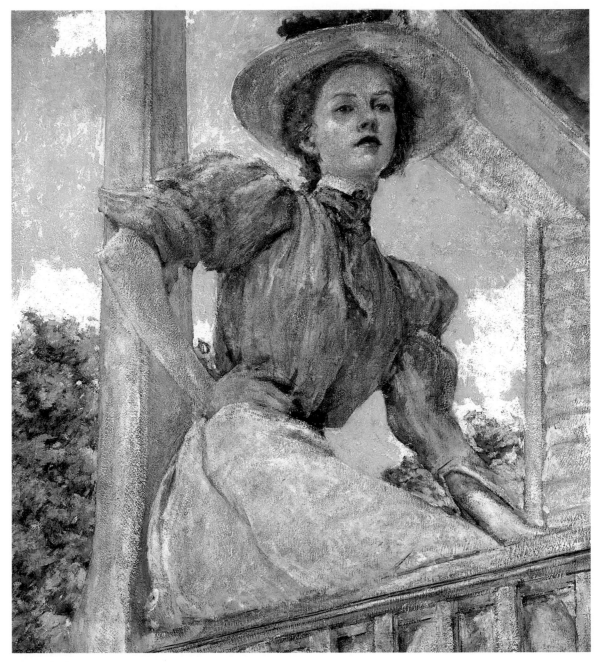

Robert Reid, SUMMER GIRL
oil on canvas, 36½ × 32¾ inches, Collection Sewell C. Biggs.

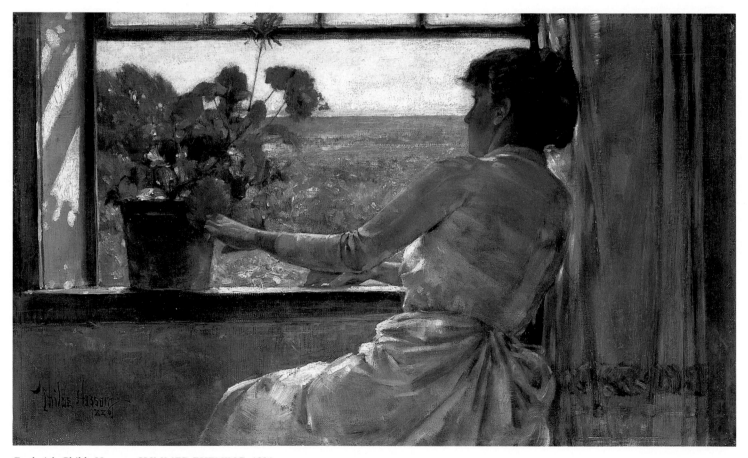

Frederick Childe Hassam, SUMMER EVENING, 1886
oil on canvas, 12⅛ × 20¼ inches, Collection J. V. Hawn.

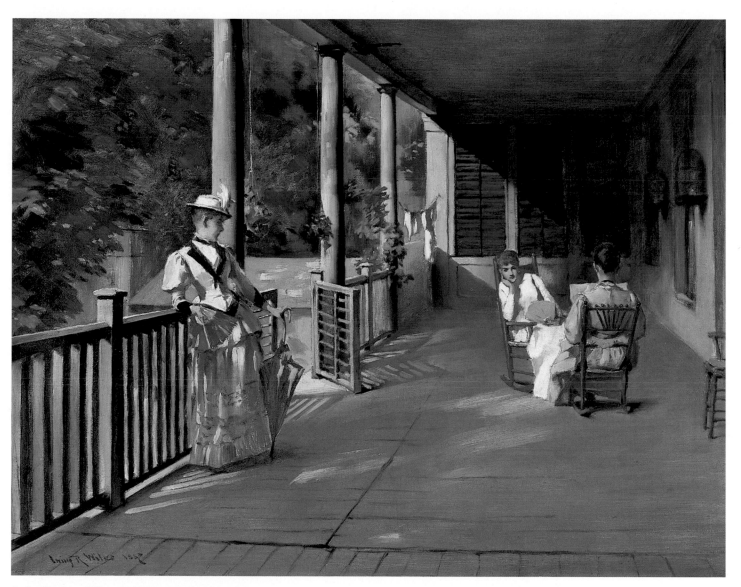

Irving Ramsay Wiles, ON THE VERANDA, 1887
oil on canvas, 20 × 26 inches, Courtesy John E. Parkerson & Co.

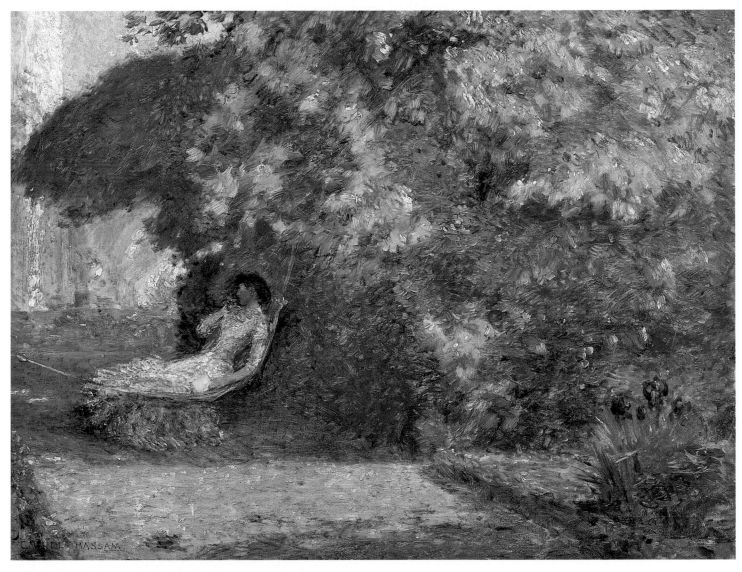

Frederick Childe Hassam, UNDER THE LILACS, ca. 1887–1889
oil on panel, 10⅝ × 16½ inches, The Snite Museum of Art, University of Notre Dame,
Gift of Mr. and Mrs. Terrence J. Dillon.

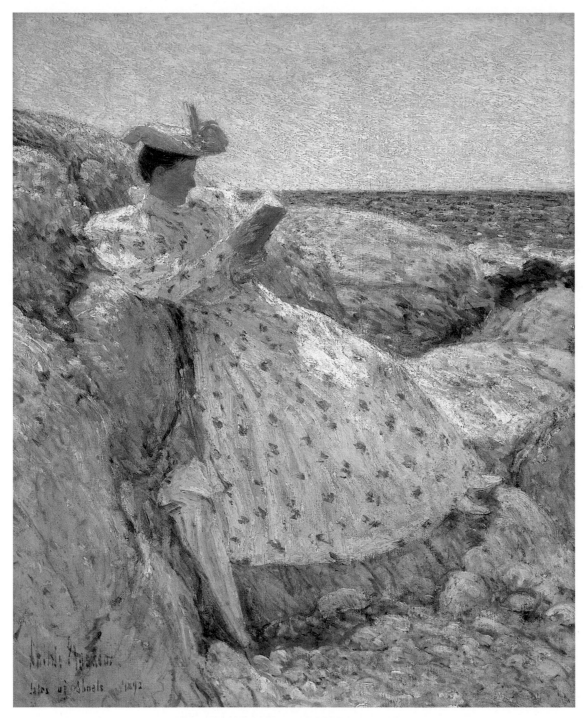

Frederick Childe Hassam, SUMMER SUNLIGHT [ISLES OF SHOALS 1892], 1892
oil on canvas, 23 × 19 inches, The Israël Museum, Jerusalem, Gift of Mrs. Rebecca Shulman, New York.

Reading

Inevitably, the Industrial Revolution had a major effect on almost every aspect of the lives of Americans. For the affluent it resulted in more time for leisurely pursuits and more products available for their "conspicuous consumption." Many turned to reading during leisure hours, and their choice of reading material was unprecedented in volume and scope. Steam-powered presses had improved printing methods, particularly lithography and photoengraving, making the process more efficient and less expensive. As one contemporary magazine editor noted, "books keep tumbling out from the presses faster than ever, and of course, a man who thinks that he has a mind is bound to feed it part of the time on books."[1] Impressive libraries were formed by the very wealthy, and anyone of social standing considered reading not only a moral obligation but, more important, a social imperative.

Earlier in the century, the classics were considered of prime importance; since reading them required that a considerable amount of time be spent in learning the dead languages, they had an "honorific value."[2] By the 1890s, however, with the proliferation of literary production and because of less stringent social standards, conditions had changed, as reported in *Scribner's* in 1893: "There is nothing any longer except the Bible and Shakespeare that the contemporary American need blush not to know. If he has intelligence and reasonable culture the presumption will be that if he has not read this it was because he was busy reading that, or was more profitably occupied than in reading either."[3]

Before the 1880s Americans favored English authors such as Burns, Carlyle, Dickens, Thackeray, Browning, Kipling, and Robert Louis Stevenson. In part this might be attributed to the preference for all things English; something more practical, however, was ultimately responsible for the proliferation of books by English and other foreign authors. Before the International Copyright Law of 1891, American publishers pirated popular foreign publications and, without having to pay expensive royalties to their authors, published them at a lower cost than those by American writers. Books by Hardy, Tolstoy, Dostoyev-ski, Flaubert, and Zola were pirated and widely distributed. Flaubert's *Madame Bovary* and Zola's *Nana,* published in America in the 1880s, each sold nearly a million copies.[4]

With the change in the copyright laws and a growing nationalistic spirit in the United States in the 1890s, American authors, writing about characteristic American types and situations, became more popular — among them Hamlin Garland, William Dean Howells, and F. Hopkinson Smith, as well as Mark Twain, James Fenimore Cooper, and Nathaniel Hawthorne, who are better known today. English writers, however, particularly Dickens, continued to maintain an especially strong following in this country.

Certain books were recommended for men, while others were advised for women or children. Considered a leisure-time activity rather than an intellectual pursuit with a practical value, reading for pleasure was generally more closely associated with women and children, who had the most spare time, as typified in Edmund Tarbell's *Three Girls Reading*. For the upwardly mobile businessman, time devoted to reading for enjoyment was considered by some to be time wasted, while others defended it: "If, business done, and the business hours spent, a business man chooses, in the privacy of his own home, to divert himself with Shakespeare, instead of playing with his children, or drowsing over his newspaper, or going into society, oftentimes he may."[5] Those men involved with the arts who were able by reading to mix business with pleasure were an exception, as is seen in J. Carroll Beckwith's *Portrait of William Anderson Coffin*. As a painter and, even more important, as an art critic, Coffin found it necessary to keep abreast of recent publications devoted to art. He was also interested in serious literature illustrated by American artists, and in 1892 he published an article devoted to this subject in *Scribner's*.[6] Another artist, Childe Hassam, though primarily known as a painter, also worked as an illustrator early in his career and had strong literary connections. While teaching watercolor in Boston in the 1880s, he had as one of his students the writer Celia Thax-

ter, who had gained some reputation for her book *Among the Isles of Shoals* (1873) and a volume of poetry, *Driftwood* (1879). Both were inspired by the vigorous terrain of her beloved island, Appledore, the largest of a group of islands making up the Isles of Shoals and located about ten miles off the Maine–New Hampshire coast. In 1848 her family had established a hotel there called Appledore House, which by the late nineteenth century had become a summer haunt for artists and literati, including the Boston-based painters Ross Turner, J. Appleton Brown, and Ignaz Marcel Gaugengigl, as well as the writers James Russell Lowell and Richard Watson Gilder. Hassam first visited Appledore House in 1884 and returned frequently thereafter.[7] In 1892 he painted *Summer Sunlight*, choosing as his subject a graceful young woman reading on a rugged shoreline, enjoying not only her reading material but the summer sun and sea air as well. William Dean Howells, the editor of the *Atlantic Monthly* and later of *Harper's Monthly Magazine*, appealed to novelists to "concern themselves with the more smiling aspects of life, which are the more American . . . the large, cheerful average of health and success and happy life."[8] The books of Louisa May Alcott, whose heroines are "robust and sensible," were particularly appealing to younger women.[9] Hassam's painting portrays a similarly robust and sensible young woman, as do those by Lillian Genth and Robert Reid.[10]

Adventure stories were recommended for stimulating the minds of youths, and European authors and themes were among the most popular, with such books as Robert Louis Stevenson's *Treasure Island* (1892) and Rudyard Kipling's *Jungle Book* (1894) meeting that need. In James J. Shannon's painting *Jungle Tales,* of 1895, the artist has depicted his wife reading what is very likely Kipling's book to their young daughter, Kitty (depicted in profile), and another child, who sit listening intently to each exciting word.[11] Although Kipling's books engaged the attention of spirited youths of both sexes, genteel boys were more affected by another publication, *Little Lord Fauntleroy*, written by Mrs. Frances Hodgson Burnett and first published as a serial in *St. Nicholas Magazine* in 1885. Later published in book form, *Little Lord Fauntleroy* became a cherished role model: "many American mothers above a certain income level not only took him to their hearts but socially crucified their boy children by putting them into black velvet and never allowing their hair to be cut."[12]

Whether for man, woman, or child, there was ample reading material available at the turn of the century, with social dictates often governing choice. For members of the leisure class, the focus was on the positive, fashionable, and proper — at a time when what was considered proper in literature was beginning to be more liberally interpreted.

Clarence White, THE READERS, 1897
The Licking County Historical Society, Newark, Ohio.

Edmund Tarbell, THREE GIRLS READING, 1907
oil on canvas, 25 × 30 inches, Private Collection.

Lillian Genth, PORTRAIT
oil on canvas, 35 × 29¹⁄₁₆ inches, Henry Art Gallery, University of Washington,
Horace C. Henry Collection.

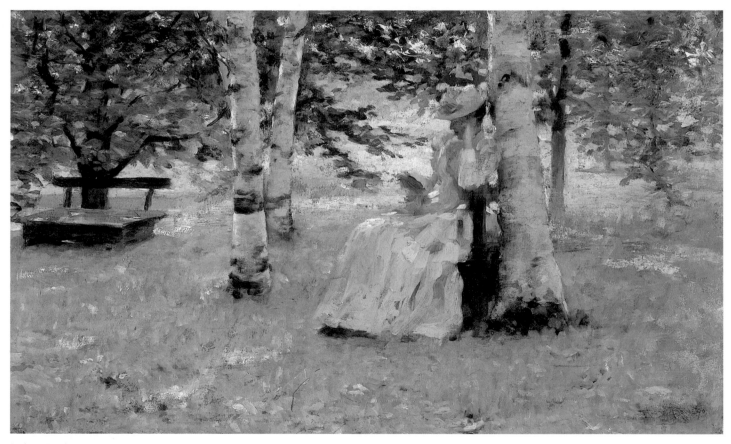

Robert Reid, REVERIE, 1890
oil on wood panel, 12 × 20 inches, Private Collection.

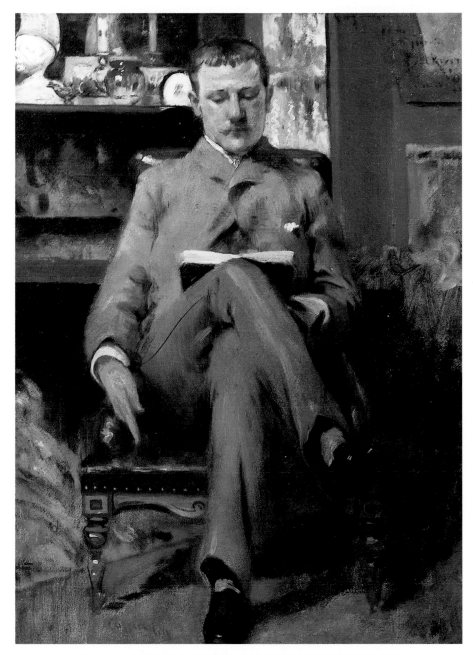

James Carroll Beckwith, PORTRAIT OF WILLIAM ANDERSON COFFIN, 1885
oil on canvas, 20 × 15 inches, Private Collection, New York.

Clarence White, MISS GRACE, ca. 1898
platinum print, 7⅞ × 5⅝ inches
Collection The Museum of Modern Art, New York.
Gift of Mrs. Mervyn Palmer.

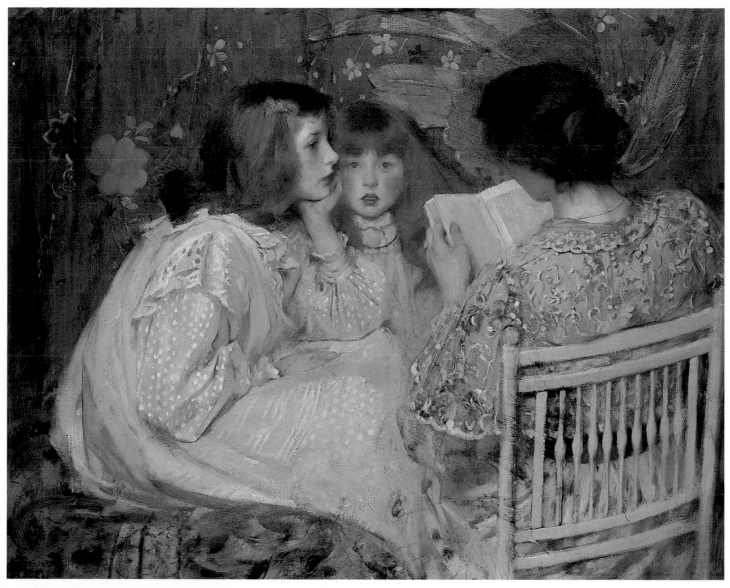

James Jebusa Shannon, JUNGLE TALES, 1895
oil on canvas, 34¼ × 44¾ inches, The Metropolitan Museum of Art, New York, Arthur Hoppock Hearn Fund, 1913.

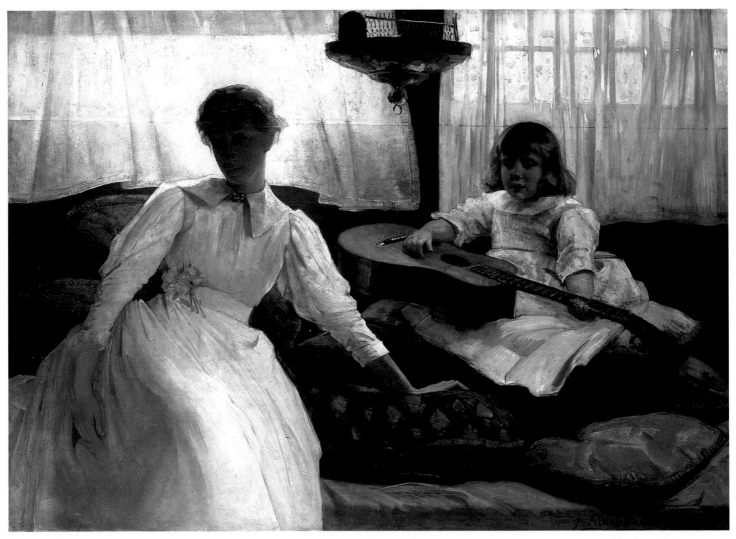

Julian Alden Weir, IDLE HOURS, 1888
oil on canvas, 51¼ × 71⅛ inches, The Metropolitan Museum of Art, New York, Gift of Several Gentlemen, 1888.

A Musical Interlude

Close on the heels of America's Industrial Revolution came its cultural revolution, with art and industry vying for the public's attention at the Centennial Exposition. Fine and decorative arts received special notice, and music appreciation gained momentum. In 1881 a writer for *Scribner's* confidently proclaimed: "Americans are certainly a music-loving people. They are particularly susceptible to the sensuous charm of tone, they are enthusiastic and learn easily, and with the growth in general culture of recent years, there has sprung up a desire for something serious in its purpose in music, as in other arts."[1] As with most other leisure activities of the period, men had less time than women to indulge in musical pursuits. The same writer elucidated: "The incessant pressure of work which every American feels prevents men from paying much attention to music." He predicted a change, however: "As the country advances in age and begins to acquire some of the repose which age brings, there will come possibilities of development."[2] Evidently he was right. Little more than a decade later it was reported that the division of labor made the working man's day shorter. For many men faced with the question of how to utilize this free time in a stimulating way, music, "with its elevating influences," became the answer.[3]

Aside from formal portraits of professional musicians, American paintings showing men playing musical instruments are relatively rare compared to similar depictions of women. Those that do exist are often linked in some way to the artist's own aesthetic life. For instance, Dennis Miller Bunker's *The Guitar Player* and Stacy Tolman's *The Musicale* both depict intimate events that took place in the artists' studios. Tolman's painting provides a relatively formal view of three amateur musicians probably playing a classical arrangement. In contrast, Bunker depicts a solitary male, posed casually with a guitar and most likely playing a lighter tune. Clarence Cook, a critic of the period, welcomed the informal air the guitar could lend to parlor entertainment. He admonished: "modern formality, and too frequent absence of hearty enjoyment in our social meetings, formulates itself in our music, which like everything else nowadays, is becoming so learned and laborious that instead of being a relaxation it is only a continuation of the day's tasks to listen to it." Advocating the use of less formal musical entertainment, he questioned: "Have we not too long restricted ourselves to the pianoforte as an accompaniment in our parlor music? Would not some other instrument be welcome even in our public concerts?" Cook also praised the "picturesque charm" of the guitar, with its free and graceful lines.[4]

Certainly the pictorial quality of the guitar must have been one of J. Alden Weir's considerations when he included one in his painting *Idle Hours*. In this work Weir depicts his wife, Anna, and their first daughter, Caroline, peacefully lounging in a plush domestic setting. The undulating lines of the guitar the child holds on her lap complement the soft curves in the composition, while the instrument's large size emphasizes the diminutive scale of the young girl. The guitar is also a symbol of cultivation, indicating the social status of the artist's leisure-class life.

In addition to commenting on the graceful lines of the guitar, Clarence Cook attributed similar aesthetic qualities to several other instruments — the harp, the violin, and the cello — observing "how easily they lend themselves to the movements of grace and beauty, how their lines blend with the lines of the human form!"[5] This observation is particularly pertinent when these lines are compared to those of the female form, and some of the most fashionable artists of the day took advantage of this likeness by posing women with these instruments, which also served as symbols of gentility and culture. John White Alexander, in *A Ray of Sunlight,* merged the curves of the cello with those of his young model, creating a refined image of lithe beauty. Similarly, Thomas Dewing, in *The Song,* employed the gentle shape of the lyre, an ancient Greek instrument of the harp family, to enhance the elegant lines of his female figure.

Equally genteel but more modern in conception is Dewing's *Brocart de Venise (Venetian Brocade).* As the title indicates, the artist's main interest is the opulence of a patrician interior and, therefore, the lavish life-style of wealthy Americans — all portrayed, of course, in a most tasteful manner. By the time Dewing painted this work,

the social significance of having a piano in one's home was less great than it had once been. With technical progress and growing prosperity in America, pianos became less expensive and could be found in nearly every respectable parlor. The favorite, the upright, was considered to have the best tone.[6] More concerned with the visual quality and the aesthetic effect of the instrument, Dewing chose to depict the more delicately proportioned square piano in his painting.

It is evident that other leisure-class individuals seriously interested in music preferred the upright piano, as may be seen in Charles Ulrich's *Moment Musicale* and Stacy Tolman's *The Musicale*. Its appearance could easily be improved if its top was used for the display of fine porcelain and other decorative wares, and its simple presence could be enhanced if it was surrounded by Oriental vases and other objets d'art, which also served as further evidence of affluence and culture.

It was estimated in 1887 that half a million people in America were taking piano lessons, and according to a more recent source, "the number of pianos in use in American homes increased more than five times as fast as the population" in the decade between 1890 and 1900. This increase could, in part, be attributed to the influence of the World's Columbian Exposition of 1893.[7] Undoubtedly the most momentous event of its kind ever to be staged in America, the fair attracted twelve million visitors. At the fair a wide variety of distinguished musical performances were given by professional musicians from around the world, and local bands and orchestras from all parts of the nation were in attendance. Consequently the sale of musical instruments and sheet music rose dramatically in the succeeding decade as prosperous Americans who had sufficient leisure time became amateur musicians, with the piano remaining the favorite instrument.[8]

By the second decade of the twentieth century, the piano had become a familiar fixture in homes of even the working class. As one writer observed, "It was not always played; the minor profiteers of the first World War would install one as an emblem of mild prosperity and garnish its top with framed photographs and geegaws."[9] Thus the piano, once considered a rare and valuable instrument that only wealthy people could afford, was reduced to being a piece of furniture used to emulate the status it had earlier provided for the leisure class.

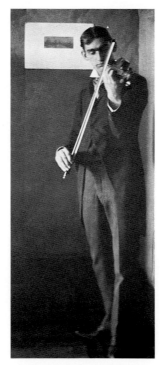

Clarence White, THE VIOLINIST, 1897
platinum print, 7⅞ × 3⅜ inches
Collection The Museum of Modern Art,
New York. Purchase.

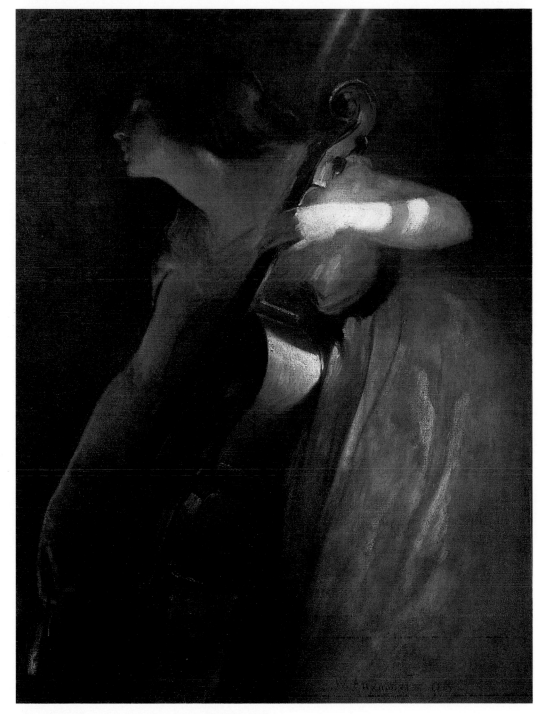

John White Alexander, A RAY OF SUNLIGHT, 1898
oil on canvas, 48 × 35 inches, Private Collection.

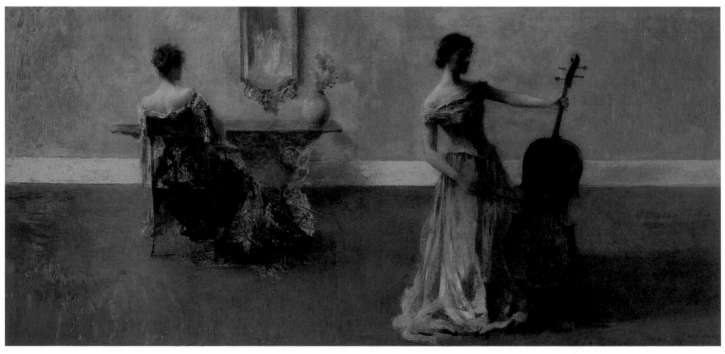

Thomas Dewing, MUSIC, 1915
oil on panel, 12 × 26 inches, Private Collection.

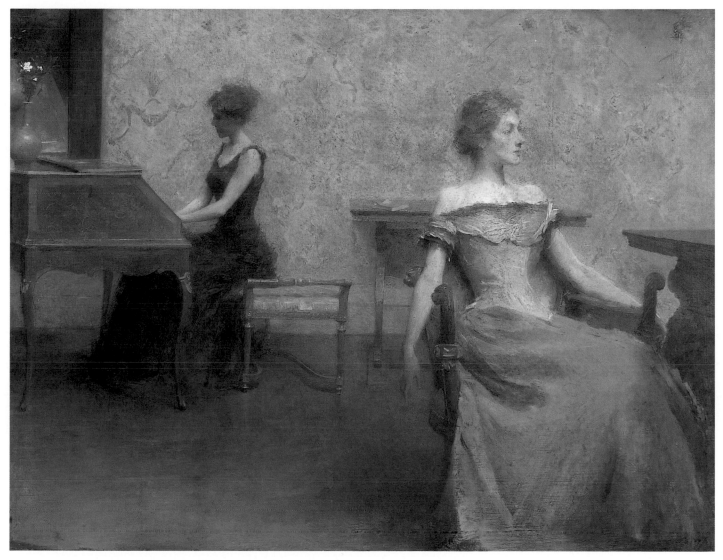

Thomas Dewing, BROCART DE VENISE (VENETIAN BROCADE), ca. 1905
oil on board, 19⅜ × 25⅝ inches, Washington University Gallery of Art, Gallery Purchase, Bixby Fund, 1906.

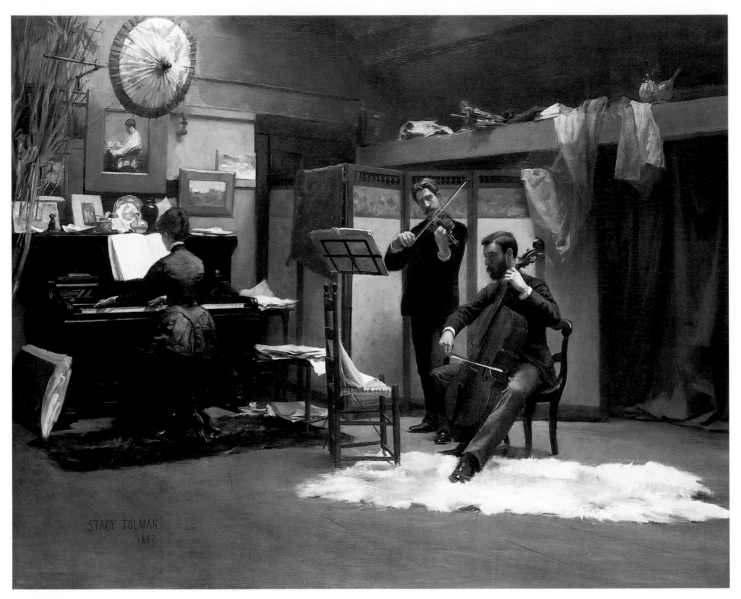

Stacy Tolman, THE MUSICALE, 1887
oil on canvas, 36⅛ × 46⅛ inches, The Brooklyn Museum, 51.211, Dick S. Ramsay Fund.

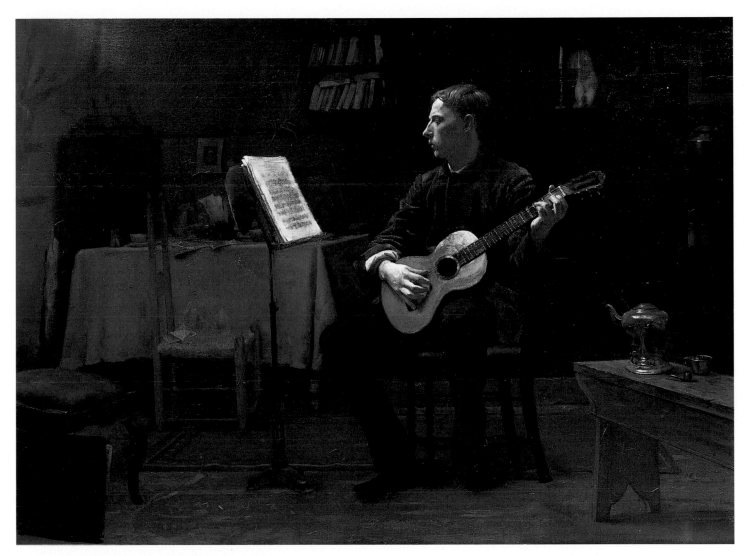

Dennis Miller Bunker, THE GUITAR PLAYER, 1885
oil on canvas, 26⅛ × 36⅛ inches, Private Collection, New York.

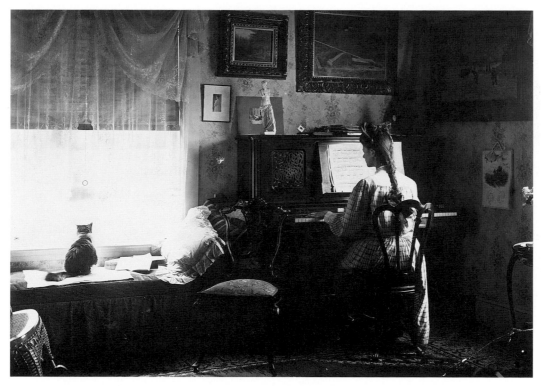

Chansonetta Emmons, DOROTHY AT THE PIANO AT 21 BENNINGTON STREET, NEWTON, MASSACHUSETTS, ca. 1908
Culver Pictures.

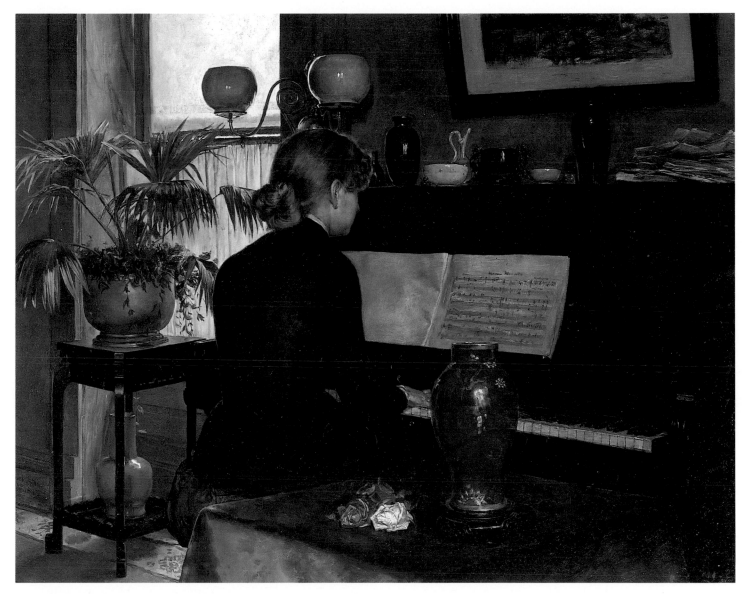

Charles Frederick Ulrich, MOMENT MUSICALE, 1883
oil on panel, 14⅞ × 19¼ inches, The Fine Arts Museums of San Francisco,
Gift of Mr. and Mrs. John D. Rockefeller III.

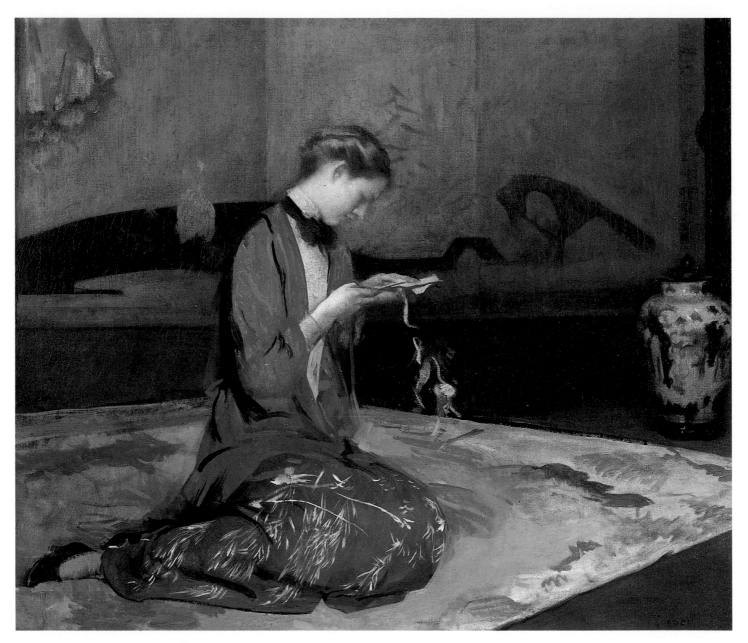

Edmund Tarbell, CUTTING PATTERNS, ca. 1908
oil on canvas, 25 × 30 inches, Collection Mr. and Mrs. Ralph Aryeh.

Aestheticism

Women, especially those of the leisure class, played an important role in the aesthetic movement in America. As Thorstein Veblen explained, "the cultivation of the aesthetic faculty requires time and application," and no one in America had more leisure time than the genteel woman.[1] Aside from overseeing her duties in the domestic sphere, the woman of the house was allowed, or even expected, to engage in certain leisure-time activities, described by Veblen as "quasi-scholarly and quasi-artistic."[2] Magazines such as the *Art Amateur* provided a variety of decorous pursuits as well as instruction; among the many popular books of this sort were *The American Girls Handy Book* and *What a Girl Can Make and Do,* both written by Lina and Adelia Beard, which devoted chapters to "How to Paint in Watercolors," "How to Paint in Oil Colors," "How to Model Clay and Wax," "How to Make Plaster Casts," and even how to make monotypes. Other chapters dealt with decorative arts, giving advice on painting china, designing scrapbooks, and making book covers. Another pastime for genteel women was the cutting of decorative patterns in paper, a purely ornamental pursuit that can be seen in Edmund Tarbell's *Cutting Patterns*. In this painting a young woman dressed in a Japanese kimono displays not only her leisure-class skill but a refined taste for Oriental costumes and decorations.

The serious interest in aesthetic pursuits on the part of genteel American women during the late nineteenth century can be traced to the Centennial Exposition. By the time of the Exposition, the sewing machine had been perfected to such a degree that Americans were buying half a million of them a year. In fact the display of sewing machines at the Centennial Exposition was so vast that it was reported to have extended half a mile, and it was considered by one genteel observer to be "an oppressive sight."[3] In contrast to this display of America's technological development was that provided by England's South Kensington School of Art Needlework, as well as the similarly impressive exhibits of other European decorative arts. The culturally astute were made painfully aware of

America's inferior contribution in this area, and it was this cognizance that "struck forcibly a few ladies of cultivation and public spirit" and inspired them to form the New York Society of Decorative Art the following year.[4]

The new organization, led by the spirited Candace Wheeler, was devoted to the encouragement of decorative handwork made by women and intended to provide a means for its display and sale. Mrs. Wheeler and her society created a new outlet for serious and talented women, which she claimed "broadened the narrow lives so many had been following. . . . A woman who painted pictures, or even china, or who made artistic embroideries, might sell them without being absolutely shut out from the circle in which she was born and had been reared." Wheeler cautioned, however, that "she must not supply things of utility — that was a Brahmanical law."[5]

As America moved swiftly into the machine age, Mrs. Wheeler and other leisure-class women reacted by reviving such handicrafts as embroidery, and found them to be not only acceptable but very timely endeavors. Their skills and talents were much in demand by members of their own leisure class who objected to machine-made products because of the "commonness of such goods." As Veblen explained: "What is common is within the [pecuniary] reach of many people. Its consumption is therefore not honorific."[6] Whether intended for sale or merely as a means of demonstrating one's leisure-class status, embroidery (though considered by some to be the "comparatively unimportant sister of painting") became the fashion.[7] While in earlier years it had been sufficient for a woman to prove her wealth by purchasing handmade goods, now it was necessary for her to prove that she had enough leisure time to make them herself — one example of the fact that conspicuous leisure was surpassing conspicuous consumption in importance among the social elite. It was also a means by which some women could participate in America's cultural development.

Authors such as the Beards devoted chapters in their books to needlework, providing both old-fashioned and new patterns and designs. Magazines such as *Scribner's*

published articles on the craft, recommending designs with elegant lines and forms.[8] Some women, such as the one depicted in Charles Ulrich's painting *At the Embroidery Hoop,* chose large, ambitious projects. Others did work on a more intimate and personal scale, as seen in Irving Wiles's *Mrs. Wiles in the Garden.*

Although many wealthy American women imported their clothing from couturiers in Paris, and others engaged the services of professional dressmakers, some leisure-class women made use of their own talent by hand-stitching fancy garments. Robert Blum's pastel *Girls Sewing* ("A Chat") portrays three women in the process of doing just that. The young women are believed to be the Gerson sisters — Minnie, Virginia, and Alice — who came from a cultured family and became fashionable figures in artistic circles in New York.[9] Both Alice and Virginia also fre-

quently served as models for Blum and his artist friends, including William Merritt Chase, who later married Alice, the youngest of the three. Hand-sewn garments displayed not only a woman's taste but her talent as well, and the fact that she had leisure time to devote to such projects.

Less fortunate women quickly devised clothing for themselves and their families on their newly purchased sewing machines, using designs from the wide array of pattern catalogues produced by Madame Demorest and others and available by mail order.[10] Factory-made clothing was also widely available, but by no means was it permissible among those of the leisure class to wear machine-made garments, which were known as "reach-me-downs" because they had to be gotten down from the shelves of shops in the days before clothes hangers were invented.[11]

Gertrude Kasebier, THE GERSON SISTERS, ca. 1905
Library of Congress.

Robert Blum, GIRLS SEWING ("A Chat"), ca. 1884
pastel on paper, 14 × 9 inches, Cincinnati Art Museum, Purchased from W. J. Baer.

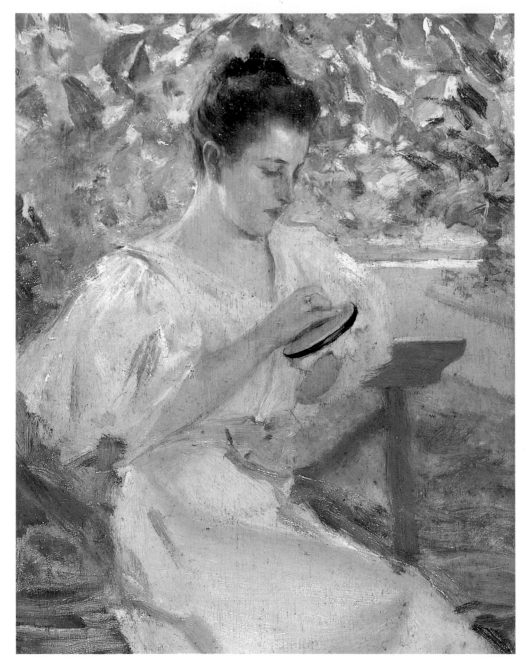

Irving Ramsay Wiles, MRS. WILES IN THE GARDEN, ca. 1895
oil on wood panel, 9 × 7 inches, File Collection, photograph courtesy R./H. Love Galleries, Chicago.

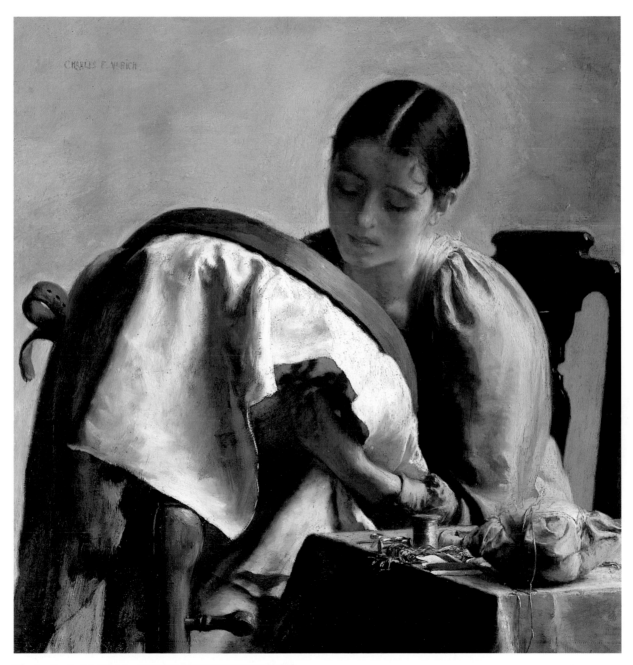

Charles Frederick Ulrich, AT THE EMBROIDERY HOOP
oil on panel, 15¾ × 14½ inches, Hirschl & Adler Galleries, New York.

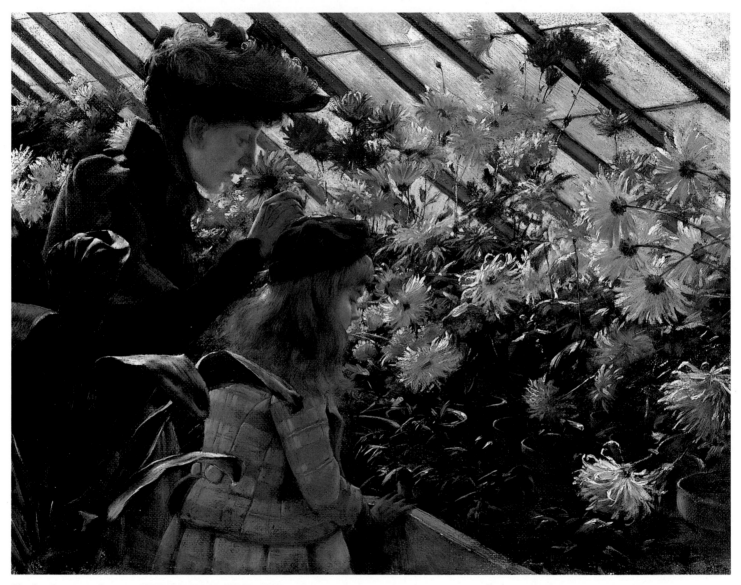

Charles Courtney Curran, CHRYSANTHEMUMS, 1890
oil on canvas, 9 × 12 inches, Private Collection.

Flora and Fauna

A woman's purpose, as explained by Thorstein Veblen, was to beautify the household of which she should be the "chief ornament."[1] Certainly there were women who chose to refute or disregard this social ideal, but most who aspired to high social status adhered to these precepts. When not actively displaying to her social peers that she had ample leisure time for entertaining or being received by her friends, the woman of affluence could pursue aesthetic and quasi-intellectual pursuits such as collecting butterflies or wildflowers. Other flower-related activities included making decorative designs for china, furniture, and embroidery, painting floral still lifes, and making floral arrangements for the home. All of these required time, application, and expense, and thus could not be indulged in by the working classes. They represented refined taste and gave useful evidence of gentility.

One of the exciting innovations of the Industrial Revolution was a new expertise with glass, cast iron, and hot-water piping, which made possible the greenhouse as well as the conservatory, a somewhat larger structure able to accommodate trees.[2] Those who could afford it attached these glass buildings to their homes, creating lavish settings for fashionable entertaining. Others leisurely visited flower shows and botanical gardens. In Charles Courtney Curran's *Chrysanthemums,* painted in 1890, a young woman and a child admire a display at one of these shows. This painting documents the popularity of the chrysanthemum as well as the interest in the modern contrivance of glass and iron that made it possible for people to extend their appreciation of a floral environment throughout the year — whether at home or in a public display.

The chrysanthemum came to America via England, in 1798. In 1884 the Massachusetts Horticultural Society produced an impressive exhibition of many varieties in its fall show, and the chrysanthemum was heralded as the coming flower. Another special show was put on two years later, and by the turn of the century, chrysanthemum shows were a popular event, held in major cities each fall.[3] One contemporary enthusiast explained: "The fact is the flower possesses in itself such positive merits that its position is assured beyond any cavil. It lends itself well to various kinds of cultivation; it is grown with comparative ease,

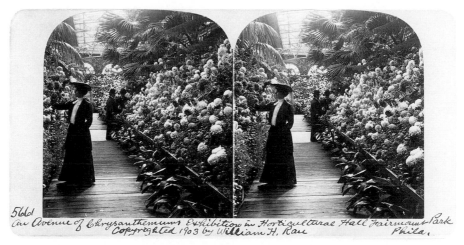

William H. Rau, AN AVENUE OF CHRYSANTHEMUMS EXHIBITION IN THE HORTICULTURAL HALL, FAIRMOUNT PARK, PHILADELPHIA, 1903
Library of Congress.

flowers profusely, and lasts well under conditions that are usually injurious to plant-life." Most important, this writer continued, "it . . . fills completely a season when flowers are few, which without it would be dreary enough."[4]

Curran's *Lotus Lilies* indicates the popularity of another flower in America at the turn of the century. One contemporary account described the lotus as "the biggest, grandest, and most effective" of all lilies.[5] It had been known for millennia in Egypt and the Orient; associated with the dreamy feeling of indolence its fruit was thought to produce, it had long been used in the decorative designs of many countries. In America the flower was held in great esteem in the 1880s, when it was featured in the lakes and fountains of many city parks. Aesthetically it was considered preferable for the blossoms to appear in "clusters and not in monotonous masses extending from shore to shore."[6] The natural, overgrown setting depicted in Curran's painting suggests not a park, but a lake in the country. Although the exact location of the setting is unknown, a fine yellow lotus native to America abounded chiefly in Southern states but could also be found growing as far north as New Jersey.[7]

Unlike the women in *Lotus Lilies,* who may be gathering the spectacular blossoms for a flower arrangement, most fashionable ladies preferred expensive blooms from the florist for their displays. Indigenous wildflowers were generally deemed too commonplace for such arrangements and more suitable for such decorative uses as "menu cards," made with pressed flowers.[8]

Finally, on a quasi-intellectual level, collecting butterflies and wildflowers, then identifying them and mounting them in a decorative manner, became a popular pastime for the leisure class, especially women. Such naturalistic pursuits can be seen in Winslow Homer's *The Butterfly Girl* and in De Scott Evans's *Botanizing.* The latter activity was particularly recommended on several accounts. Primarily, the collecting and classifying of plants according to Linnaeus's system was a time-consuming venture that could only be indulged in by the leisure class; second, it provided women with a modicum of intellectual stimulation; and third, it was a healthful endeavor that provided exercise and clean, fresh air.

In England, Linnaeus's terms served yet another function, becoming "the language of love" by which lovers would send messages "in code."[9] Given the tendency of Anglophiles among the American elite to adopt all things English, it is likely that this practice traversed the Atlantic with other English customs.

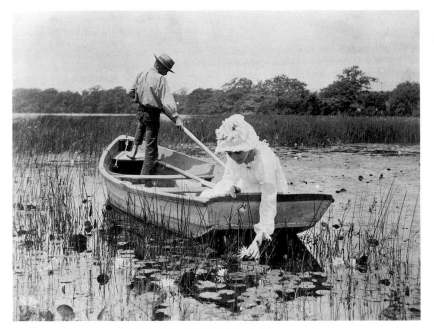

Rudolf Eickemeyer, Jr., THE LILY GATHERER, 1892
Library of Congress.

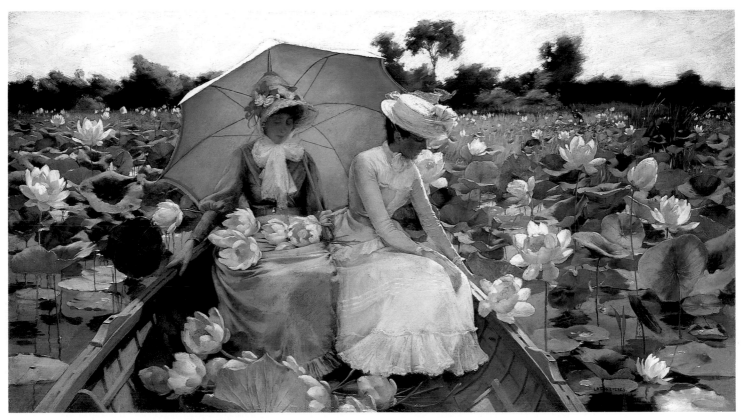

Charles Courtney Curran, LOTUS LILIES, 1888
oil on canvas, 18 × 32 inches, Daniel J. Terra Collection, Terra Museum of American Art, Chicago, Illinois.

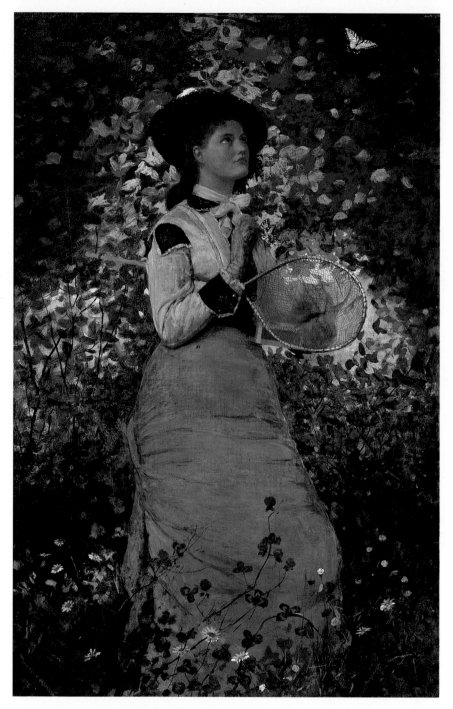

Winslow Homer, THE BUTTERFLY GIRL, 1878
oil on canvas, 37½ × 23½ inches
The New Britain Museum of American Art, Gift of Friends of William F. Brooks.

Jane Peterson, HOLLYHOCK GARDEN
oil on canvas, 40 × 30 inches, Private Collection.

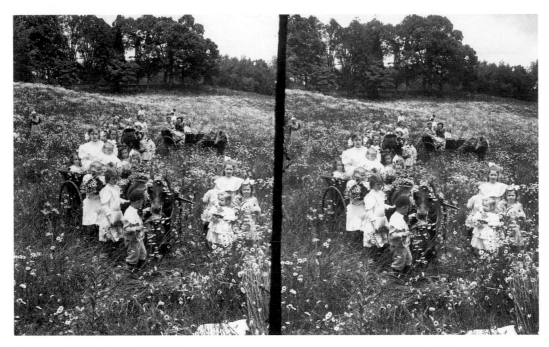

Underwood & Underwood, Publisher, CHILDREN PICKING FLOWERS IN A FIELD, 1905
Library of Congress.

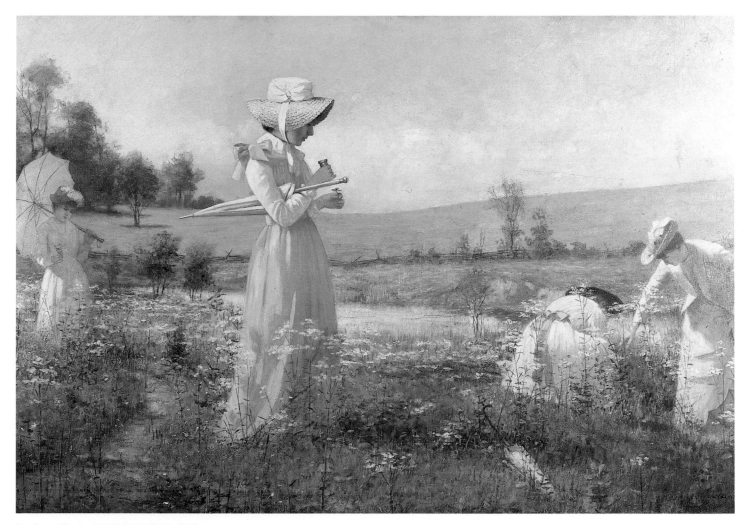

De Scott Evans, BOTANIZING, 1891
oil on canvas, 24 × 36 inches, Collection Harry and Bernice Glass.

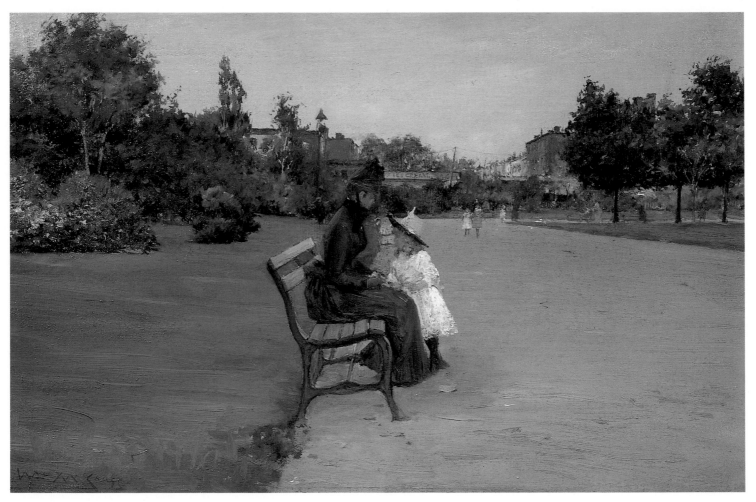

William Merritt Chase, PROSPECT PARK, ca. 1885–1886
oil on wood panel, 6¼ × 16 inches, Private Collection.

In the Park

In 1853 thirty-three proposals were submitted to the commissioners of New York's Central Park as development plans. Greensward, the design chosen, was entered by Frederick Law Olmsted and Calvert Vaux. Their concept was in part derived from plans used for English parks, with broad promenades for public walks. It was also within the tradition of America's parklike cemeteries, including Mt. Auburn in Boston (1831) and Greenwood in Brooklyn (1840), which provided pastoral settings where people could retreat from busy city streets.

There was at the time a definite distinction perceived between a public park (intended to be ornamental and soothing to the senses) and a public playground (designed for physical activities). Aware of the need for both but also sensitive to the inherent conflicts between the two, Olmsted and Vaux provided a plan that would serve these two capacities: the "receptive" and the "exertive." While part of the park was devoted to "the tranquility of the promenade and contemplation," other areas were allocated for games and sports.[1] With a clear physical separation between these two spaces, the park could serve both needs harmoniously.

For the most part, the success of Central Park was overwhelmingly acknowledged, as was that of Prospect Park in Brooklyn, also designed by Olmsted and Vaux. Artists of the period, among them William Merritt Chase and Maurice Prendergast, called attention to the beauty of these two parks, which set the standard for many other city parks in America.

Chase began painting scenes in Prospect Park in the mid-1880s, focusing on the quietude and solace of its broad walkways and promenades. In 1890, after moving from Brooklyn to Manhattan, Chase shifted his attention to Central Park. By this time, however, critics were complaining that the balance of the receptive and exertive functions envisioned by Olmsted and Vaux had been upset, and that the active aspect of the park was intruding upon the contemplative. One writer reminded New Yorkers and others: "The truest value of public pleasure grounds for the large cities is in the rest they give to eyes and mind,

to heart and soul."[2] Indeed, this was a major concern of the designers of Central Park, and Chase and others continued to portray relatively sedate activities rather than exertive sporting events. In his *Lilliputian Boat-Lake — Central Park,* Chase created a charming rendition of children sailing boats on a small pond that was originally called Conservatory Water.[3]

In 1891 Chase began spending his summer months at Shinnecock Hills, Long Island, which became the new setting for his plein-air paintings. Maurice Prendergast, who had already been engaged in painting city-park scenes in Massachusetts, soon took up where Chase left off, proclaiming the beauty of Central Park in his delicate watercolors of the early 1900s. Prendergast, with a comparatively modern point of view, focused more directly on the lively, exertive activities to be found in the park. His paintings are buoyant, vibrant, and bursting with happy activity, as seen in *May Day, Central Park.* In this work Prendergast depicts a custom derived from ancient times, the celebration of the advent of spring. It is natural that an artist such as Prendergast would have been attracted to this colorful festivity, which was already becoming rare among all but the leisure class. Similarly, he succeeded in weaving the joy and vitality of privileged childhood into bright, decorative patterns in his carousel scenes. One, *Flying Horses,* was painted at the shore in Massachusetts. As a recent art historian has pointed out, however, "The 'Flying Horses' and their happy riders could be found any summer holiday from Central Park to Salem Willows at the amusement parks Prendergast enjoyed."[4]

For those artists who spent their summer months in the city, the parks provided a refined setting for plein-air painting, which was especially well suited for capturing the character of this optimistic era. Like some writers of the period, who believed it was particularly "American" to focus on the happy, positive side of life, artists such as Chase and Prendergast chose to follow a similar course, portraying the optimism of the gilded age.

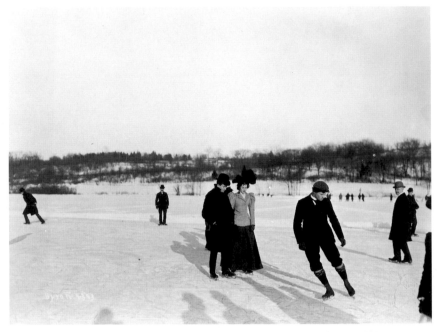

J. Byron, SKATING, VAN CORTLANDT PARK, NEW YORK CITY, 1897
The Byron Collection, Museum of the City of New York.

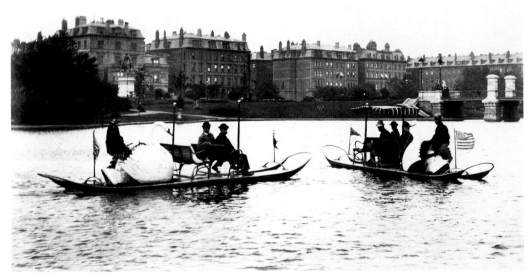

N. L. Stebbins, SWAN BOATS, THE PUBLIC GARDEN, BOSTON, 1884
Society for the Preservation of New England Antiquities, Boston.

William Merritt Chase, PROSPECT PARK, BROOKLYN, ca. 1887
oil on wood panel, 16⅛ × 24⅛ inches, The Parrish Art Museum, Southampton, New York, Littlejohn Collection.

William H. Rau, THE "KING OF BEASTS,"
CENTRAL PARK, NEW YORK, 1904
Library of Congress.

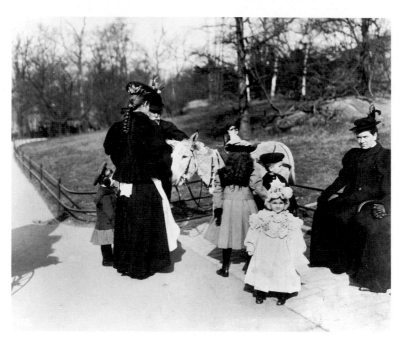

J. Byron, CHILDREN WITH DONKEY, CENTRAL PARK, 1898
The Byron Collection, Museum of the City of New York.

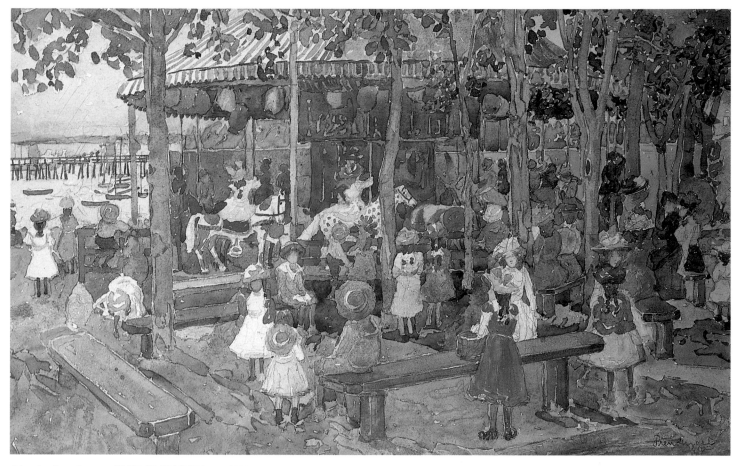

Maurice Prendergast, FLYING HORSES, ca. 1901
watercolor on paper, 13¼ × 21 inches, Murjani Collection.

T. W. Ingersoll, SATURDAY AFTERNOON
IN CENTRAL PARK, NEW YORK
Library of Congress.

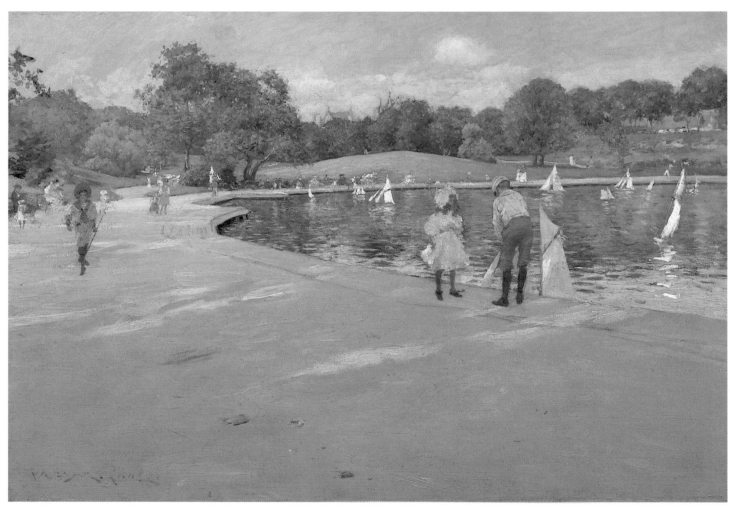

William Merritt Chase, LILLIPUTIAN BOAT-LAKE — CENTRAL PARK, ca. 1890
oil on canvas, 16 × 24 inches, Private Collection.

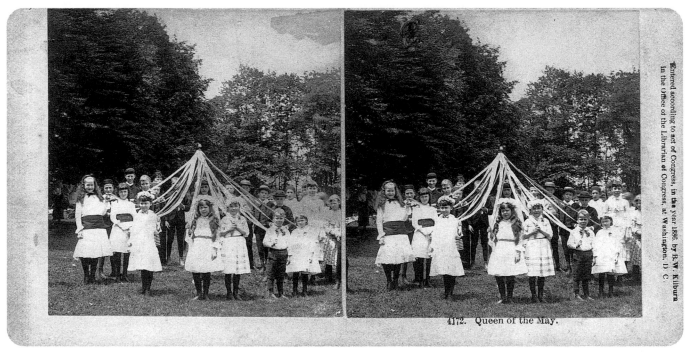

4172. Queen of the May.

B. W. Kilburn, QUEEN OF THE MAY, 1886
Private Collection.

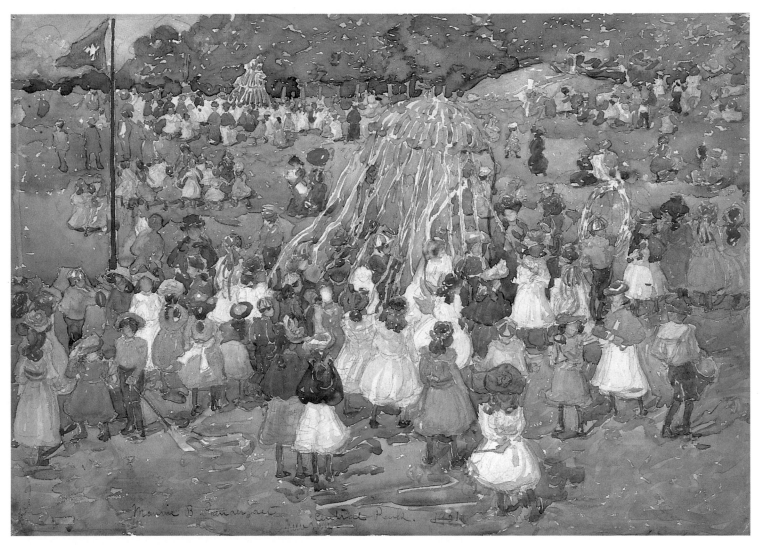

Maurice Prendergast, MAY DAY, CENTRAL PARK, 1901
watercolor on paper, 13⅞ × 19¾ inches, The Cleveland Museum of Art, Gift from J. H. Wade.

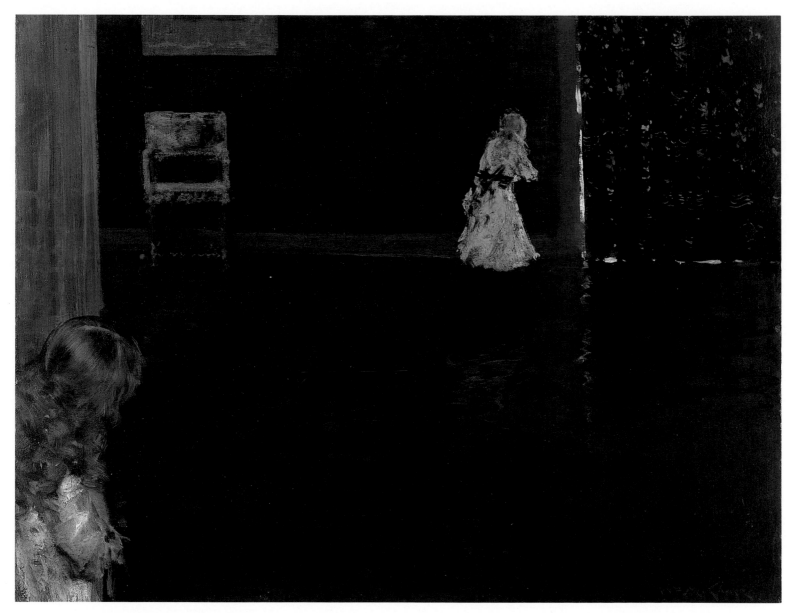

William Merritt Chase, HIDE AND SEEK, 1888
oil on canvas, 27½ × 36 inches, The Phillips Collection, Washington, D.C.

Children's Games

Toward the end of the nineteenth century, writers and social historians began referring to the passing era as "the children's century," or the "century of the child."[1] As a more recent writer explained, "when production left the household, sweeping away the dozens of chores which had filled the child's day, childhood began to stand out as a distinct and fascinating phase of life."[2] One of the few remaining domestic duties of leisure-class women was the raising of their children. All too often this meant pampering and spoiling them.

Articles in popular magazines prescribed the proper methods of entertaining children and warned of the problems that would arise — particularly with little girls — if their leisure time was not properly monitored. Constance Cary Harrison, writing for the *Century Magazine* in 1883, credited Henry James, Jr., as being "a keen observer . . . while entering his protest against the all-pervading American little girl who flies through society on roller-skates, bidding everybody get out of her way."[3]

Another writer of the period, Louise A. Chapman, published an article in *The Cosmopolitan* in 1886, titled "Proper Work and Recreation for Our Children."[4] She suggested that small tasks be assigned boys and girls, and that children be paid for performing these duties, preparing them for their roles as adults.

Thus, for the first time, a great deal of attention was devoted to the subject of children and their leisure-time activities, especially by women writers. Some stressed moderate physical exercise; others recommended games and tasks that promoted mental development. All, to one degree or another, realized the importance of providing role models and guidelines for proper social development.

In *Young Girl in Black (Artist's Daughter Alice in Mother's Dress)*, William Merritt Chase has provided us with a prime illustration of how young children were taught their future social roles and obligations. Dressed in a free-flowing gown, an overwhelmingly ornate hat, and a gold bracelet, with a fan at her side, Chase's daughter Alice Dieudonnée (looking none too happy) is prepared for her life as a genteel lady. In a similar manner, little games,

plays, and tableaux were devised for the purpose of acculturation. One contemporary author, explaining the value of children's enactment of adult roles, noted: "It is hoped that some of the plays will help to teach the children important truths that are difficult for them to learn in the abstract, but which represented and practiced in childish play may make an impression on their plastic little minds."[5]

More complex instructions for staging successful tableaux were provided in books, such as G. B. Bartlett's *Parlor Amusements for Young Folks,* of 1876, and in magazine articles, such as one published in *Scribner's* in 1880, titled "A Chapter on Tableaux."[6] Elaborate costumes and settings were required, as well as a remarkable amount of time — this was truly the epitome of a leisure-class activity. Children were taught morals, history, and art as they posed for such subjects as "Justice, Mercy and Peace" and "Milton at the Age of Ten" and reenacted famous paintings by both old and modern masters. Undoubtedly they also learned patience and endurance as they were fitted for their cumbrous costumes and sundry accoutrements.

With this special interest in childhood development, it was natural for artists of the day to direct their attention to the leisure pursuits of young children. From infancy to puberty, children provided painters with a wide array of charming and engaging subjects. Childhood innocence has always had a universal charm, and such paintings were very popular with the general public. Eastman Johnson's *Bo-Peep (Peek-a-Boo),* Thomas Eakins's *Baby at Play,* and other similar works portray infantile exploration and play in the secure confines of the leisure-class home. William Merritt Chase's paintings *Hide and Seek* and *Ring Toss* show views of parlor games for genteel children, in which their minds and coordination are exercised in a moderate and decorous manner. Similarly, Cecilia Beaux, in her painting *Dorothea and Francesca,* presents the graceful movements of two sisters, Dorothea and Francesca Gilder, as they sedately improvise a dance step.

Strenuous physical activity was generally considered to be unfeminine as well as inappropriate and potentially haz-

ardous for girls and young women. Less vigorous activities, such as ambles in the open air, as portrayed in Edith Prellwitz's *An Early Morning Stroll,* were suggested for outdoor exercise, while board games were recommended for the parlor.

Some overly cautious writers of the day even advocated restricting the physical activities of young boys. In spite of such concerns, leisure-class boys continued to find outlets for their youthful energy, but it was usually their genteel attitude that was emphasized by artists. Edward Simmons deliberately posed his young model (believed to be his son) as a miniature gentleman, in formal attire, astride a fine horse and holding what is probably his father's walking stick. Another view of the proper young gentleman is seen in George Maynard's *The Geography Student,* of 1880, in which the artist presents a type of young boy whose long hair and fancy outfit were later immortalized in Frances Hodgson Burnett's *Little Lord Fauntleroy.*[7] Undaunted by his precious coif and garb, the lad in Maynard's painting is engaged in the manly pursuit of charting worldly travel. Other educational pastimes recommended for leisure-class boys included aeronautics, acoustics, chemistry, electricity, the microscope, optical amusements, and photography.[8]

During the "children's century," games and organized forms of leisure activities became a necessary part of the lives of genteel youths. Activities stimulating physical and mental development, once a natural part of a child's life as he or she attended to chores and learned what was necessary to function as an adult, now had to be devised and formalized for leisure-class children. Most important were games that prepared them for their positions as gentlemen and gentlewomen. These games and entertainments — including the popular "tableaux vivants," which may seem frivolous to us today — represented a form of learning by doing, acting, and participating rather than by mere rote learning. Since these activities were enjoyable to children, they were effective informal ways for them to learn — to learn what was proper, to learn how to compete, to learn how to excel, and to learn how to display their prosperity as adults in a leisure-class society.

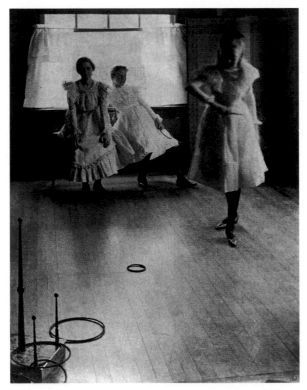

Clarence White, RING TOSS, 1899
International Museum of Photography at
George Eastman House,
Rochester, New York.

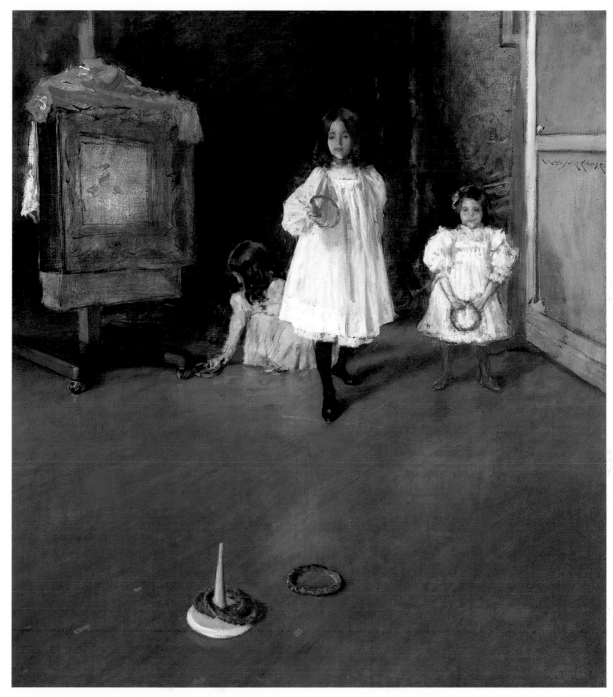

William Merritt Chase, RING TOSS, ca. 1896
oil on canvas, 40⅜ × 35⅛ inches, Private Collection, United States.

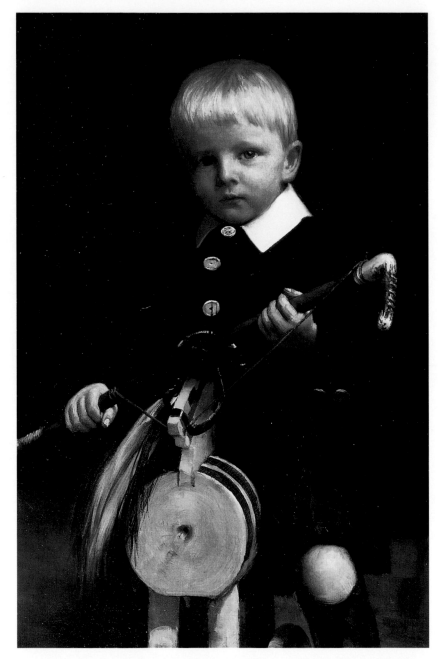

Edward Emerson Simmons, A YOUNG BOY RIDING A TOY HORSE, 1889–1890
oil on canvas, 29½ × 19¾ inches, Private Collection.

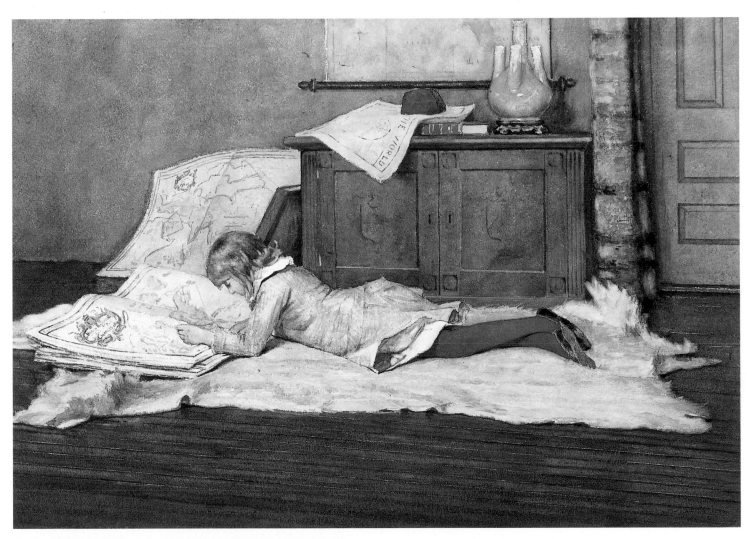

George Willoughby Maynard, THE GEOGRAPHY STUDENT, 1880
watercolor on paper, 13⁵⁄₁₆ × 19⅝ inches, Collection Mr. and Mrs. Arie L. Kopelman.

PRINCES IN THE TOWER: ROBERT CHASE (RIGHT) AND
FRIEND IN COSTUME FOR TABLEAUX VIVANT, ca. 1907
The William Merritt Chase Archives, The Parrish Art Museum,
Southampton, New York.

William Merritt Chase, YOUNG GIRL IN BLACK
(ARTIST'S DAUGHTER ALICE IN MOTHER'S DRESS), ca. 1899
oil on canvas, 60⅛ × 36³⁄₁₆ inches, Hirshhorn Museum and Sculpture Garden,
Smithsonian Institution, Gift of Joseph H. Hirshhorn Foundation, 1966.

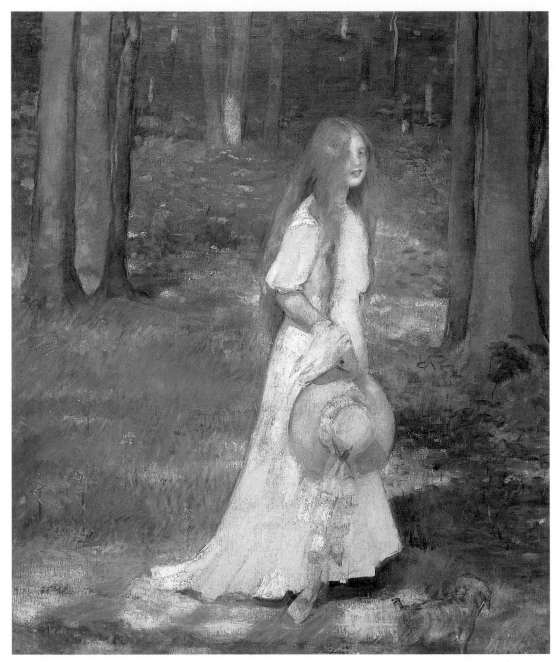

Edith Prellwitz, AN EARLY MORNING STROLL, ca. 1895
oil on canvas, 30 × 25 inches, Private Collection.

John G. Bullock, YOUNG ANGLERS, 1896–1898
platinum print, 8 × 6 inches
Collection The Museum of Modern Art, New York.
Gift of the John Emlen Bullock Estate.

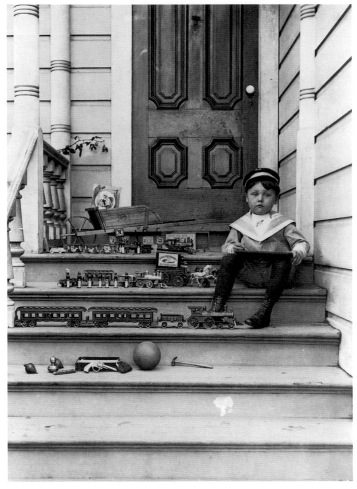

Underwood & Underwood, Publisher,
BOY ON STOOP WITH HIS TOYS, 1909
Library of Congress.

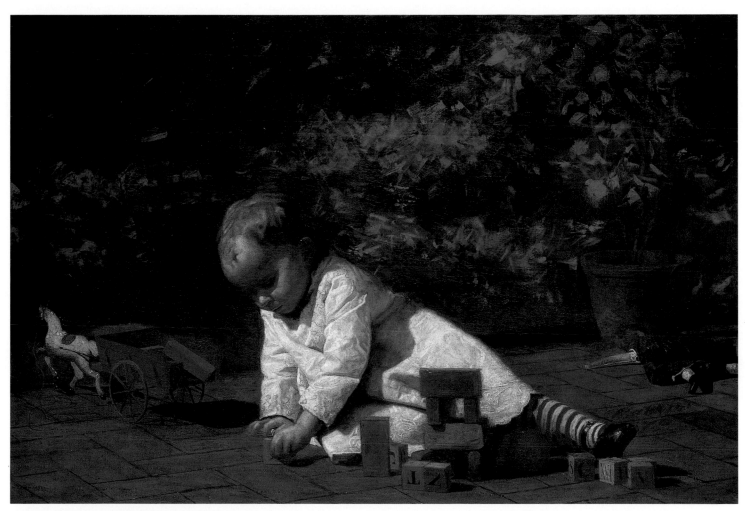

Thomas Eakins, BABY AT PLAY, 1876
oil on canvas, 32¼ × 48 inches, National Gallery of Art.

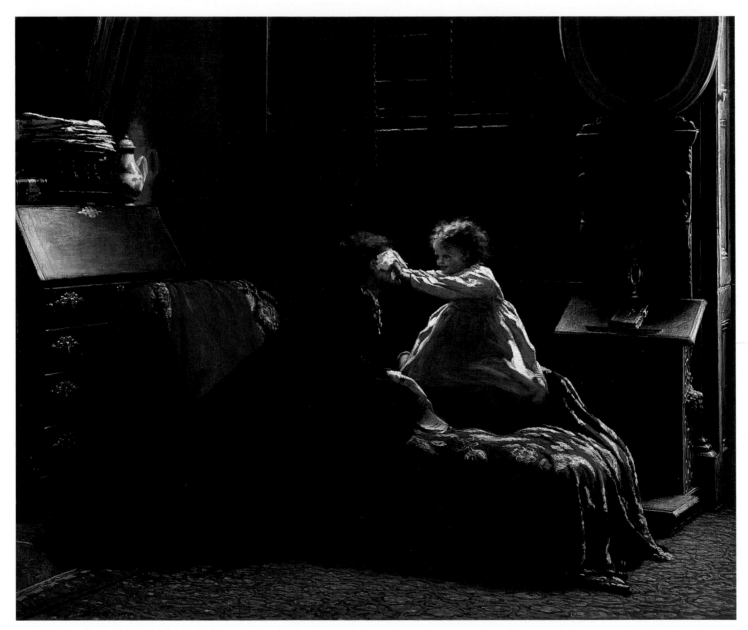

Eastman Johnson, BO-PEEP (PEEK-A-BOO), 1872
oil on paperboard mounted on panel, 22 × 25 inches, Amon Carter Museum, Fort Worth, Texas.

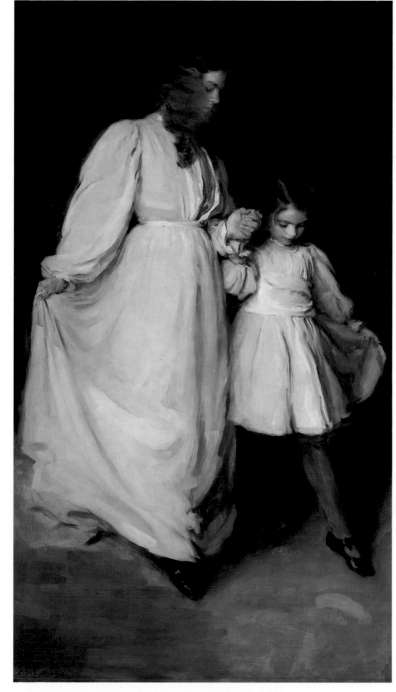

Cecilia Beaux, DOROTHEA AND FRANCESCA, 1898
oil on canvas, 81½ × 46½ inches, © 1988 The Art Institute of Chicago,
A. A. Munger Collection, 1921.109. All Rights Reserved.

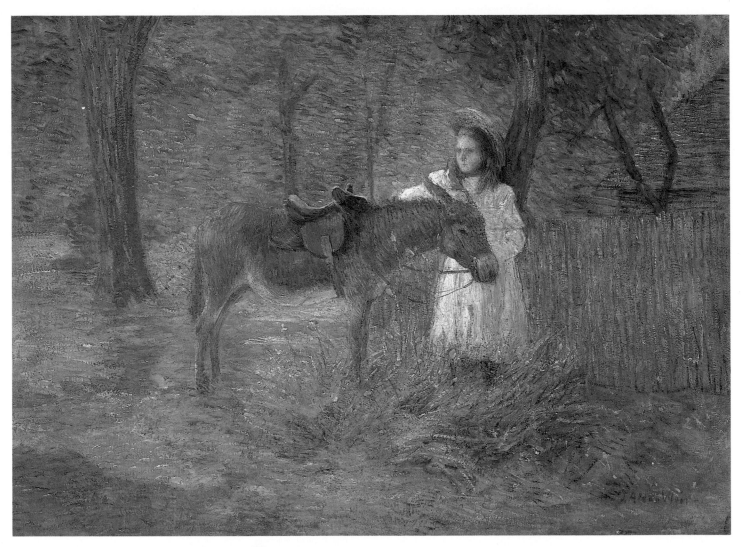

Julian Alden Weir, VISITING NEIGHBORS, ca. 1903
oil on canvas, 24½ × 34 inches, The Phillips Collection, Washington, D.C.

Pets

American artists at the turn of the century devoted considerable attention to the relationships of people and their pets, and in doing so provided us with very personal images of the period. Pets played a particularly significant role in the lives of affluent Americans in this era, especially in the lives of women and children, who enjoyed their companionship during the long hours while men were at work. Numerous books and articles proclaimed the worthiness of pets and dictated just what types were proper and fashionable.

Most highly prized were the rare and exotic breeds and species, whose only meaningful duty was to be beautiful or, at most, to entertain their masters and mistresses. Certain pets were considered more appropriate for males, while others were recommended for females. Cats were generally considered "less reputable" than dogs and other fashionable pets because they were "less wasteful" and might even serve a "useful end" — a taboo in an age of conspicuous consumption. The exception to this rule were expensive, "fanciful" breeds such as the Angora.[1] Such exotic creatures were considered compatible pets for genteel girls and women. *Every Boy's Book: A Complete Ency-*

clopedia of Sports and Amusements, published in 1869, clearly stated just which pets were suitable for young males: dogs, canaries, goldfish, guinea pigs, and, of all things, silkworms.[2] Conspicuously absent were cats.

The most popular pet of the period was certainly the dog, with one breed or another appropriate for every member of the family. Once again, the most fashionable breeds were the rarest and most exotic — and most expensive. Thorstein Veblen explained that dogs were valued because they had no practical use in the leisure-class home (apparently they were not necessary for protection). In addition, dogs were credited with having "special gifts of temperament." As we know to this day, and as Veblen expounded upon then, the dog is often spoken of as "the friend of man, and his intelligence and fidelity are praised. . . . He has the gift of an unquestioning subservience."[3]

An acceptable dog could be purchased for as little as ten or fifteen dollars; maintaining a dog of fashion, however, as one writer warned, "is an expensive luxury in our day."[4] What type of dog to choose? Various breeds were suggested for different types of people and settings. The poodle was supposed to be a "delightful dog for a pet" for

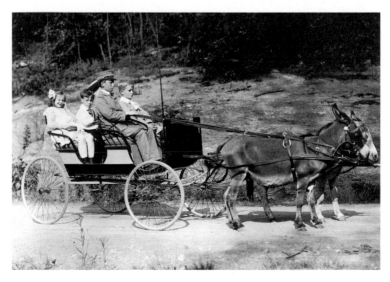

THE DONKEY RIDE, 1905
Library of Congress.

those who wanted a docile animal who was quick to learn tricks. One source pointed out that "they will even dance the polka with easy skill."[5] Spaniels were similarly praised; considered more vivacious than the poodle, they were thought to be "full of amusing tricks, affectionate, good watch-dogs, and delightful playmates."[6] The Italian greyhound, though celebrated as one of the most beautiful animals in the world, was judged "too delicate to please the taste of a boy." Boy's best friend was, instead, the bullterrier, a cross between a bulldog and an English terrier.[7] Touted as being "nearly human" (a fine trait indeed) was the cocker spaniel. The pug, if not as elegant as the Italian greyhound or as clever as the poodle, was, at least by one writer's standards, "the favorite dog of the city home."[8] The Newfoundland was popular because of its "gentleness with children."[9]

The American Impressionist painter Theodore Robinson depicts the faithful companionship offered by the dog in his painting *Miss Motes and Her Dog Shep,* painted in the fall of 1893. The artist had just returned from Giverny, where he had been painting with the French Impressionist Claude Monet. After teaching a summer class in Napanoch, New York, Robinson turned to his own work. We know by the title that the subject of this painting is a specific woman with her particular pet, probably an Airedale terrier.[10] Their relationship lends a certain charm to the work, above and beyond the artist's attempt to utilize the Impressionists' principles of conveying light and atmosphere.

Although William Merritt Chase's pastel *Good Friends* was also intended to be a study in light, it is clear from the title that there is a personal meaning to the picture as well — the emotional bond between a young girl, Chase's sister Hattie, and her pet borzoi, who rests his head peacefully on her lap. The rare breed of dog also emphasizes the leisure-class status of the genteel young girl.

The social status of the young woman in Robert Vonnoh's painting *Fais le Beau!,* in which the artist depicts his wife, Grace, in their Paris studio, is equally clear. She is elegantly dressed, surrounded by beautiful objets d'art, and playing with her pet dog. Although probably a mixed breed, this dog is obviously a spoiled favorite.

The dog's only serious rival for attention in the affluent American household was the caged bird. Canaries, highly valued as songbirds, were the most popular and the most expensive type. Parrots, with their beautiful display of plumage, were also popular and had the added advantage of being amusing. Like dogs, they were quick to learn tricks — particularly how to mimic the speech of their mistresses and masters, as well as of any member of the household. In one book on pets that devoted nine chapters to birds, the author explained their popularity: "When taken young the parrot submits readily to confinement." Like the pampered dog, the parrot "becomes a spoiled pet of the household."[11] Parrots were most prized for their human characteristics: not only could parrots talk, but they could "make use of expressions with little less than a human understanding of their significance."[12] In fact, parrots were considered to be very much like children in their "propensities for saying the most dreadful things exactly at the most inconvenient times and to the most fastidious persons, always choosing a deadly silence for making some deeply reprehensible remark."[13]

In Thomas Dewing's painting *Le Jaseur (The Gossip),* the artist has depicted the relationship between the precious parrot and its mistress in a manner different from the usual portrayal of women and children with their dogs. Besides being an indication of this woman's affluence and fine breeding, the parrot is also a symbol of the personality of its mistress — "the gossip," one who repeats indiscriminately what is heard.

During the summer months, when it was almost a moral (and certainly a social) obligation for at least the women and children of the leisure class to retreat to the country, people often adopted new pets. Children were delighted with the array of animals available to them, creatures that were not appropriate for their city homes. Racoons, skunks, and mice were readily obtainable, as was the ever-popular donkey. Aside from providing a jaunty ride, the donkey, with its stubborn nature, offered an amusing challenge for indulged children used to getting their own way.

J. Alden Weir, who used his daughter Cora and her pet donkey as the subject of *Visiting Neighbors,* painted at the family's summer farm in Branchville, Connecticut, has provided a charming image of a young girl and her seasonal pet. Duncan Phillips, a collector and friend of Weir's, commented on the specific inspiration for this work. It was not just a passage in an impressionistic painting, but "first and last [it was] just a vivid glimpse of the real world at Branchville . . . and of a little girl who had a good time with that particular donkey, and who used to tie it to that particular rustic fence which her daddy noticed took on just that grayish violet tone at that hour of the sunflecked green midday."[14]

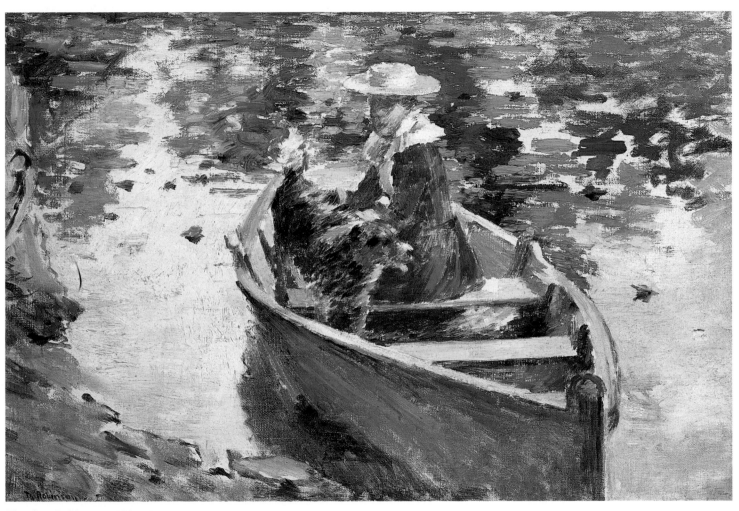

Theodore Robinson, MISS MOTES AND HER DOG SHEP, 1893
oil on canvas, 12 × 18 inches, Collection Eleanor S. May.

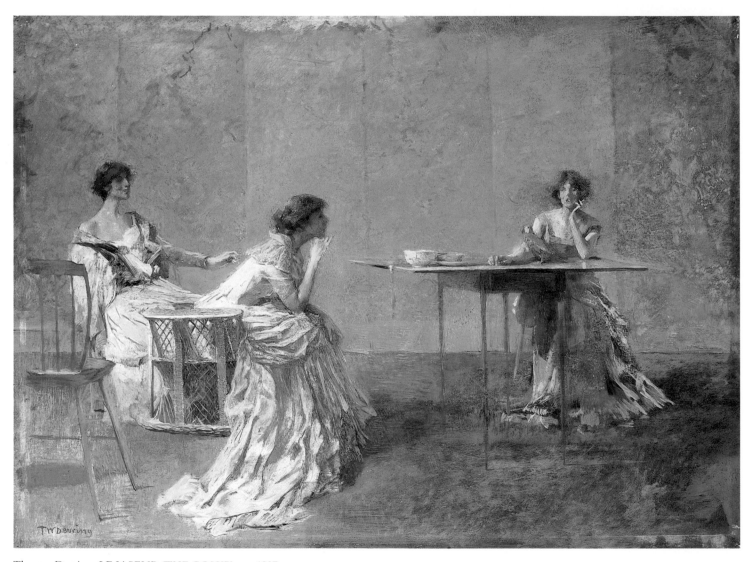

Thomas Dewing, LE JASEUR (THE GOSSIP), ca. 1907
oil on panel, 12 × 16⅜ inches, The Minneapolis Institute of Art, Gift of Margaret Weyerhaeuser Harmon.

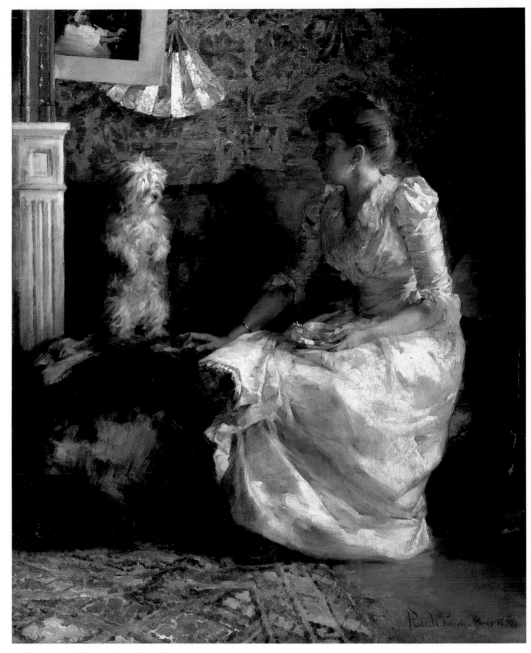

Robert Vonnoh, FAIS LE BEAU!, 1890
oil on canvas, 64 × 51¼ inches, Berry-Hill Galleries, New York.

THE CHILDREN OF LEWIS HARLOW, BOSTON, ca. 1890
Society for the Preservation of New England Antiquities, Boston.

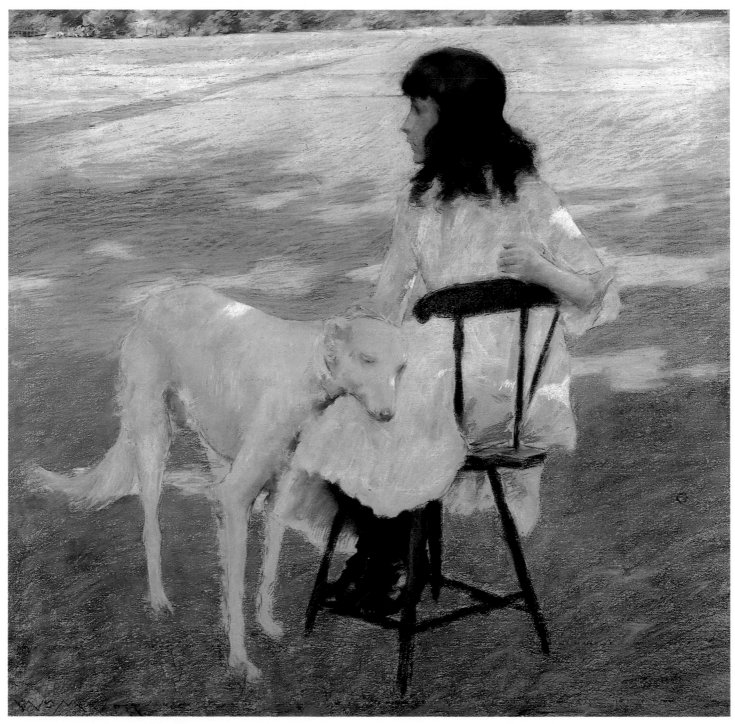

William Merritt Chase, GOOD FRIENDS, ca. 1891
pastel on paper mounted on linen, 48 × 48 inches, Joan Michelman, Ltd.

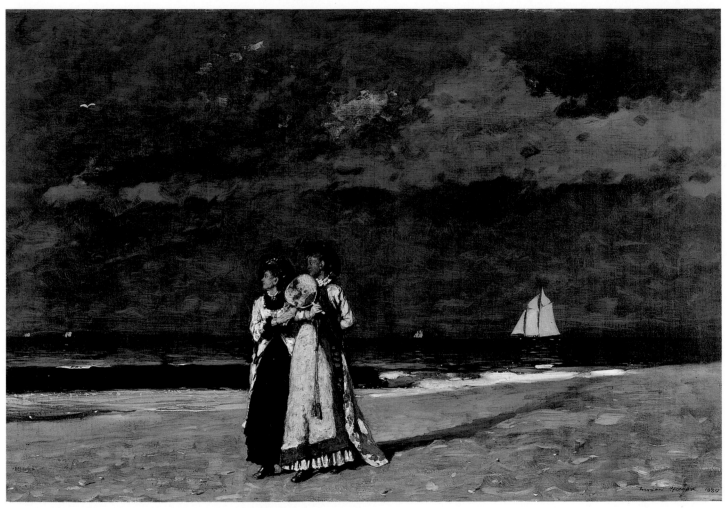

Winslow Homer, PROMENADE ON THE BEACH, 1880
oil on canvas, 20 × 30⅛ inches, Museum of Fine Arts, Springfield, Massachusetts,
Gift of the Misses Emily and Elizabeth Mills, in Memory of their parents, Mr. and Mrs. Isaac Mills.

Holidays by the Water

In the spring of 1888 *Scribner's* published an article titled "Where Shall We Spend Our Summer?" Addressing this dilemma, the author, A. W. Greely, noted: "Fifty years ago, this was a question never heard in American homes."[1] As cities grew larger and the urban population became denser, however, hygienists recommended that, when possible, everyone should spend some part of each summer in the countryside. The rapid growth and improvement of rail service and steam navigation made travel increasingly feasible for many city dwellers, and as Greely pointed out, "at one season of the year, when the mercury rises to the nineties, it is safe to say that five per centum of the entire population of the United States makes its plans and arrangements to quit regular homes for summer quarters." Greely went on to define the three classes of summer travelers. The largest group was the poorest class, "whose strength and systems, sapped and undermined by toil and trouble, and even more by unhealthy surroundings, are compelled to seek out for their brief vacations of a few days or weeks such spots as offer climatic conditions best suited to renew physical vigor and mental tone."[2] Members of this group, reported to be two-thirds of the population, generally chose inexpensive lodgings that could be reached easily and cheaply from their city homes. If they found such vacations beyond their means, they took day trips to popular beaches and amusement parks such as Coney Island. The second largest group of summer travelers, the middle class, most often chose quaint villages along the East Coast, from Nova Scotia to New Jersey, or inland watering places. There they spent the summer months engaged in sports and other simple pastimes.

The last and smallest portion of the urban population, the "fashionable folk," migrated not only for comfort but for social reasons as well, as one contemporary writer explained: "The people of leisure, for whom it is only a matter of fashion and who seek in the country the wordly life which is no longer possible in the city, take themselves to famous resorts upon the seashore or to watering places frequented by their class."[3] Although financially speaking their choices might have been unlimited, socially they were indeed circumscribed, as the leisure class was known to follow "the latest freak of fancy," whether it be "the Springs of Saratoga . . . the sands at Long Branch . . . the beach at Newport, or . . . the rocky shores of Mount Desert [Island]."[4]

Of all the fashionable summer resorts, Newport was generally considered to be sovereign — that is, for those who could afford it — for it was in Newport, as Mrs. M. E. W. Sherwood advised the readers of her etiquette book, *The American Code of Manners* (published in the early 1880s), that "etiquette reigns supreme." Her explanation was simple, concise, and decisive: "It is elegant, refined, exclusive . . . it is the queen of all watering places in this country or Europe."[5]

At least one conservative Boston critic, writing for the *Boston Sunday Herald,* had a very different opinion of Newport, complaining about the "frivolous and . . . luxurious habits" associated with New York society. He asserted that in contrast, Nahant, on Boston's North Shore, "maintains the pristine dignity and aristocratic quality which have given Boston her fame among cities." Unlike Newport, the more reserved Nahant was described as a place where "people are not in a rush and turmoil over hunts and parades and sumptuous entertainments, but where they live in quiet ease, having indeed entertainment, but not such as puts life to confusion."[6]

Artists such as Maurice Prendergast and A. T. Bricher painted scenes of Nahant and other fashionable beaches on the coast of Massachusetts, some of which were becoming far less exclusive by the 1890s. Revere Beach, developed as a resort in 1875 by the Boston Land Company, "blossomed" in the 1880s and soon became overcrowded as it "stomped to the pounding pulse of the big city exploding to escape from its ever more unbearable self."[7] In spite of this situation, Maurice Prendergast chose to portray a more sedate view of Revere Beach, with children and elegant women lounging on the sand and walking along the shore. The vast multitude is merely suggested by the densely populated corner of the pier seen in the distance. Frank Benson provides a more personal shoreline view in

his painting *Summer Afternoon,* of 1906. In this work he presents his three daughters posed languidly on the grassy dunes of his summer residence, Wooster Farm, located on North Haven Island, Maine.[8] Like Prendergast's painting, this work depicts the leisure moments of affluent women and children as they enjoy the fresh sea air while shielding their fair skin from the harsh summer sun with parasols. Winslow Homer, in selecting the setting for his painting *Promenade on the Beach* (thought to be based on sketches he made at Yarmouth, Massachusetts), chose a more secluded beach, as seen at the end of the day. The women pictured, described by Homer himself as being of "good moral character," stroll along the deserted beach while looking out to sea. When asked just what they were observing, Homer replied, "They are looking at anything that you want to have them look at, but it must be something at sea and a very proper and appropriate object for girls to be interested in."[9]

Although both Homer and Bricher worked briefly on Long Island's eastern shore, it was the gentleman-artist William Merritt Chase who had a summer home in this area for more than a decade and captured its genteel air in his leisure-class genre paintings. During the 1870s, when Homer visited East Hampton, and the 1880s, when Bricher worked in Southampton, these two villages were just becoming popular with the social elite. By the 1890s, when Chase settled into his summer home in Shinnecock Hills, just outside the village of Southampton, the region had become a favorite summer resort for New York City's affluent residents.

The quiet dignity and refined attitude of summer life in Southampton is best typified in Chase's renditions of the leisurely pursuits of his own family. Chase captured their carefree lives, both indoors and outdoors, as candidly and spontaneously as if with a camera, focusing exclusively on their ideal quietude. This mood, epitomized in his painting *Idle Hours,* is pervasive in nearly all of Chase's work, and most emphatically in the scenes he painted in Southampton between 1891 and 1902. The figures in *Idle Hours* — his wife, his children, and most likely his sister-in-law — lounge in the sand dunes not far from their summer home. The halcyon life of the leisure class is captured here, as elegantly attired women and children complacently pass the time in the open air.

For the most part, Chase and other American Impressionists emphasized the bright side of life, concentrating on the dazzling effects of sunlight and the relatively untroubled and joyous life of the leisure class. A perfect example of this is Frank Benson's *Summer Day.* In this work he has combined a casual attitude with a refined posture to create an elegant yet informal statement. Frederick Frieseke, in *Under the Willows,* presents an equally fashionable portrayal of two lovely young women. Unlike the women in Benson's painting, however, with their spirited demeanor, those in Frieseke's work are locked into a decorative pattern, serving as a reminder of the social rigidity that dictated the lives of many women of the period.

Similarly fashionable scenes were created by other artists of the time, including Walter Russell, who, in *At the Seashore,* once again chose to portray the refined and relatively quiescent attitude of figures seated and strolling along the shore.

Rarely did artists direct their attention to people actually bathing, until the twentieth century, when this became a common feature in the work of artists such as Edward Potthast, as witnessed in his painting *A Holiday*. This can be attributed in part to a change in social mores, but it was also due to a growing willingness among some artists to portray more middle-class subjects and activities. *Holiday on the Hudson,* by George Luks, reflects this change in attitude, replacing the graceful but generally sedentary poses of the nineteenth century with the comparatively awkward movements of America's growing middle class as it took advantage of increasing leisure time.

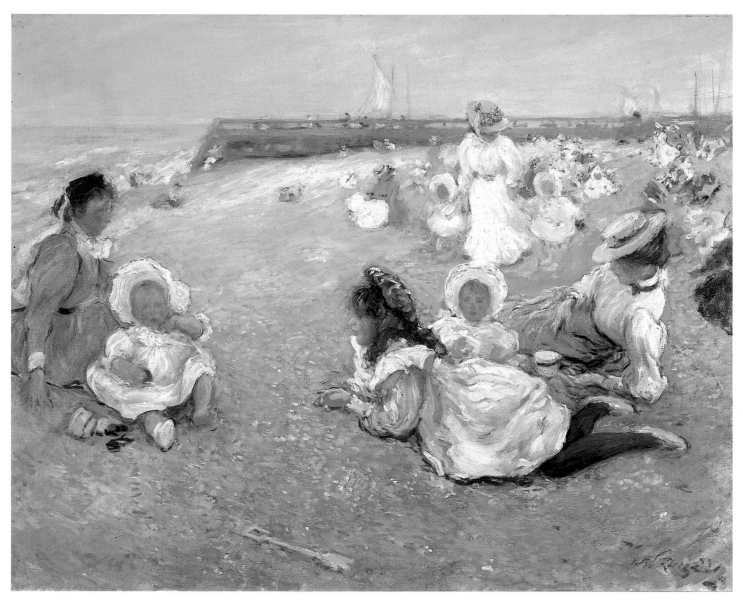

Walter Russell, AT THE SEASHORE, ca. 1898
oil on canvas, 28¼ × 36 inches, Collection Dr. and Mrs. John J. McDonough.

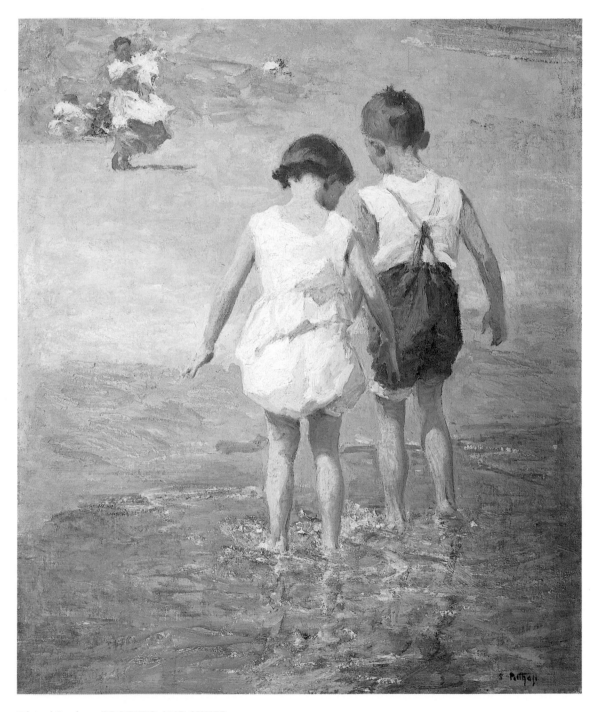

Edward Potthast, BROTHER AND SISTER
oil on canvas, 24⅛ × 20⅛ inches, Cincinnati Art Museum, Bequest of Mr. and Mrs. Walter J. Wichgar.

Harris, SEA URCHINS, 1897
Library of Congress.

Edward Potthast, A HOLIDAY, 1915
oil on canvas, 30¹⁄₁₆ × 40¹⁄₁₆ inches, © 1988 The Art Institute of Chicago,
Friends of American Art Collection, 1915.560. All Rights Reserved.

Frank Benson, SUMMER AFTERNOON, 1906
oil on canvas, 30½ × 39½, Private Collection.

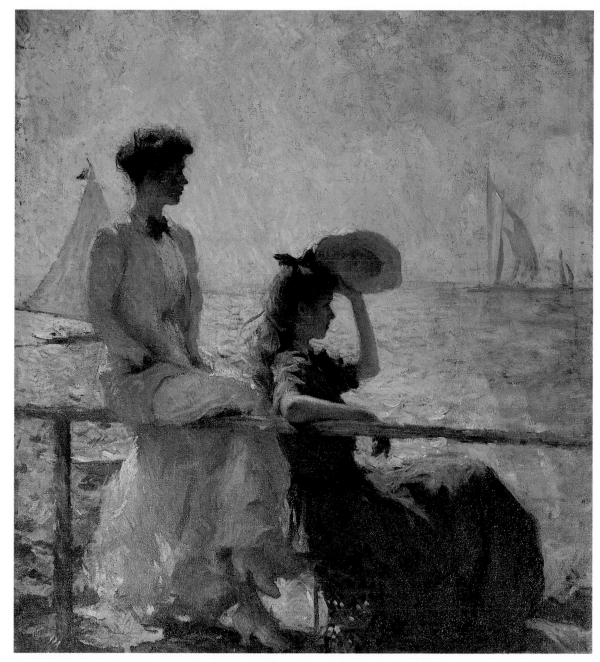

Frank Benson, SUMMER DAY, 1911
oil on canvas, 36⅛ × 32⅛ inches, Collection Mr. and Mrs. Raymond J. Horowitz.

J. Byron, BATHING, MIDLAND BEACH, STATEN ISLAND, 1899
The Byron Collection, Museum of the City of New York.

Maurice Prendergast, REVERE BEACH, 1896
watercolor on paper, 10 × 14 inches, Berry-Hill Galleries, New York.

WATCHING SAILBOAT RACES AT MINNETONKA, ca. 1900
Minnesota Historical Society.

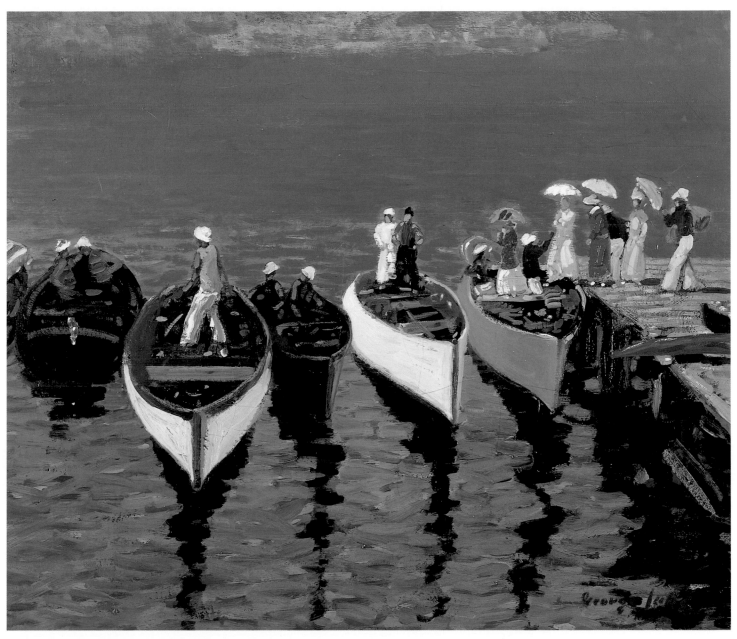

George Luks, HOLIDAY ON THE HUDSON, ca. 1912
oil on canvas, 30 × 36⅛ inches, The Cleveland Museum of Art, Hinman B. Hurlbut Collection.

12464—"Far from gay cities and the ways of men."

Keystone View Company, Publisher, FAR FROM GAY CITIES AND THE WAYS OF MEN, 1903
Library of Congress.

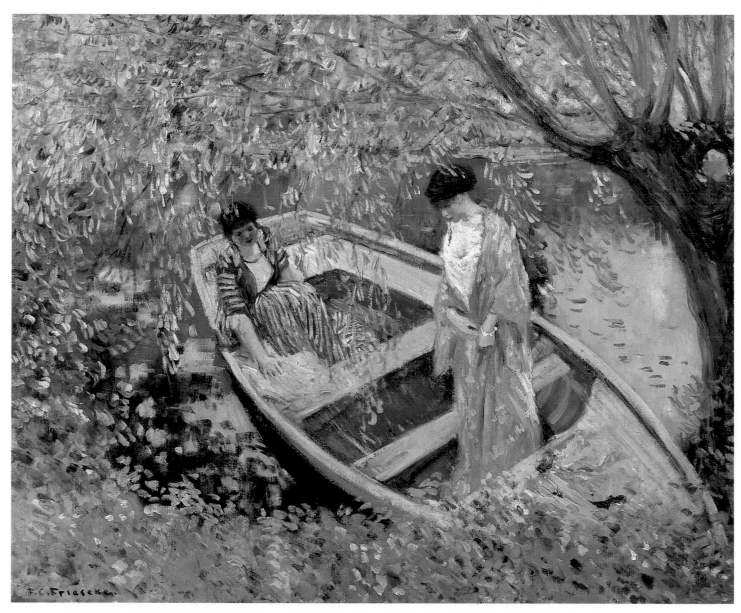

Frederick Carl Frieseke, UNDER THE WILLOWS
oil on canvas, 26 × 32 inches, Annual Membership Fund, Cincinnati Art Museum.

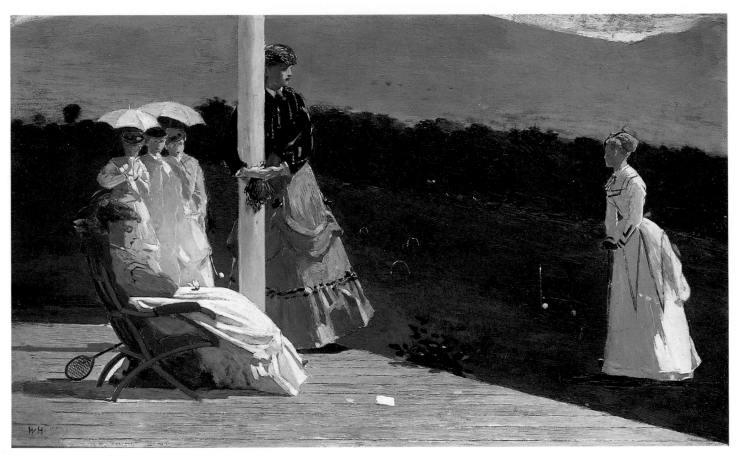

Winslow Homer, CROQUET MATCH, 1867
oil on panel, 9¼ × 15¾ inches, Daniel J. Terra Collection, Terra Museum of American Art, Chicago, Illinois.

The Sporting Life

In the early part of the nineteenth century, Americans had little time for games or organized sports of any kind. By midcentury, however, when there was growing prosperity and more leisure time, sporting activities became socially acceptable, even popular, as the leisure class indulged in what Thorstein Veblen called "decorous recreation." This form of social activity had only two prerequisites: "ulterior wastefulness" and "proximate purposefulness."[1] Many sports still enjoyed today were first introduced in the latter half of the nineteenth century.

Roller-skating, introduced by Eastern Seaboard society, became the craze of the 1860s, quickly spreading across the country. Large arenas were constructed, including one in Chicago that reportedly could accommodate a thousand skaters and three thousand spectators.[2] Other spectator sports became popular as well, such as cricket, which received passing attention in the 1860s and 1870s but was soon surpassed by baseball and football as favorite sports at Ivy League schools. By the late 1860s such fashionable city clubs as the New York Athletic Club were established, and by the late 1880s country clubs were being founded throughout America.

Among those activities recommended for gentlemen were "athletic sports and manly exercises" such as angling, archery, fencing, rowing, bicycling, cricket, croquet, football, golf, and tennis, as well as, for the very wealthy, playing polo and driving horse-drawn carriages.[3] Although physical activities for gentlewomen were at first relatively limited, by the turn of the century conditions had changed. In fact, sports proved to be an area of increasing emancipation for women. Many of the sports recommended for gentlemen became acceptable for women as well, including fishing, rowing, fencing, tennis, and golf. "Courting activities" such as croquet, roller-skating, ice-skating, and bicycling provided acceptable opportunities for young men and women to meet each other.

Croquet, introduced to the United States from England in the 1860s through illustrated rule books, was one of the first leisure-class activities that allowed respectable women to engage in athletics alongside their male counterparts. The amorous undertones of this game, along with its graceful movements and colorful equipment, attracted the

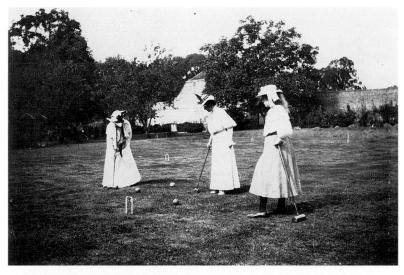

General DeWitt Clinton Falls, THE CROQUET LAWN, RIVENHALL, 1907
Photography Collection, Miriam and Ira D. Wallach Division
of Art Prints and Photographs,
The New York Public Library, Astor, Lenox and Tilden Foundations.

attention of painters and illustrators of the period, most notably Winslow Homer, who based a series of paintings on this theme.[4] Nevertheless, a wider range of sporting activities soon replaced croquet in importance as a "courting sport," and by the late 1880s both men and women had begun to abandon the croquet fields for the more exclusive golf courses and lawn-tennis courts of fashionable country clubs.

Among the early golf courses to be established in America was the Shinnecock Hills Golf Club, on the eastern end of Long Island in the township of Southampton, New York. The genesis of this club is attributed to Duncan Cryder, who, along with William K. Vanderbilt, Jr., and E. S. Mead, traveled to Europe in 1889 to find someone to lay out the course. A twelve-hole course (later expanded to eighteen holes) was completed in 1891 by Willie Dunn, and a clubhouse was designed by the fashionable architect Stanford White. Soon afterward a nine-hole course for women was completed, and golf quickly became a popular sport of the leisure class.[5] By 1893, just two years after the founding of the Shinnecock Golf Club, a writer for *Lippincott's* reported: "Golf has charms for more people than that tame and spiritless game [croquet]." Furthermore, as the same writer pointed out, golf was less physically demanding than tennis, and it could be played at any age.[6]

Tennis was introduced to the American socialite Miss Mary Outerbridge by several British officers in Bermuda in 1873. When she returned to New York the following February, she brought the game back with her, and her brother, A. Emilius Outerbridge, laid out a court (the first of its kind in this country), at the Staten Island Cricket and Baseball Club.[7] In 1881 the newly established United States Lawn Tennis Association held its first national tournament in Newport, demonstrating tennis's acceptance as a sport of the social elite.[8]

In Robert Vonnoh's painting *The Ring,* of 1892, the equipment used in racket games is included merely to indicate the refined nature of the gentlewomen portrayed. The true subject of the work, as indicated by the title, is the engagement ring on one of the young women's fingers. Gazing intently at this precious gift and symbol of intent, the other young women respond to its social significance as well as its intrinsic beauty. The casual elegance of this work might be contrasted with the more formal and active theme of George Bellows's *Tennis at Newport,* of 1920, painted nearly two decades later. In Bellows's painting an actual lawn-tennis match on a formal court is depicted, with spectators surrounding it. Both in style and in boldness of composition, Bellows has provided his viewer with a modern and vigorous portrayal of postwar aristocracy in America engaged in the serious pursuit of leisure.

An even earlier indication of the vitality of the leisure class was the enthusiasm with which Americans took up bicycling. This sport was introduced to the United States by the Hanlon Brothers (whose bicycle design was aptly referred to as the "bone shaker" because it did not have rubber tires). Unlike most fashionable trends, in which the upper class generally set the standards that the rest of America strove to attain, bicycling, in its early, unper-

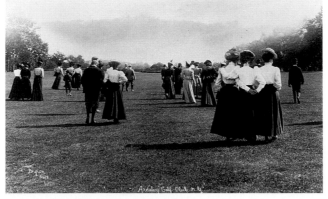

J. Byron, WALKING ON THE LINKS, ARDSLEY GOLF CLUB, NEW YORK
The Byron Collection, Museum of the City of New York.

fected stages, was championed by the masses before it was espoused by the usual arbiters of good taste. It was two decades before the bicycle's design was perfected, eventually resulting in the "safety" bicycle, which was considered practical for all, including leisure-class women. Bicycling soon became the favorite sport of the 1890s and the particular rage of such fashionable summer resorts as Southampton, with one writer for the *Southampton Press* reporting in 1897 that bicycling had become so popular that it was detrimental to the steamship companies, which sadly avowed that "thousands of Americans will stay home this year and inspect their country on a wheel."[9] Although three countries were reported to have claims to inventing the bicycle, by 1880 the United States was proud to proclaim it "an American institution."[10]

Although some sports were popular with women, others were restricted exclusively to men. Yachting, horse racing, playing polo, and driving fashionable coaches had the added distinction of being sports open only to the wealthiest. The first required considerable leisure time and the money to maintain an expensive yacht; the latter three involved the ownership and use of fast horses with pedigrees that might challenge those of their masters.

Polo, adapted from similar games played in Tibet, China, and India, was introduced to England in the 1860s. With the growing fashion for all things English among the leisure class in the United States, it was natural that polo should soon become popular in America. The socialite James Gordon Bennett, Jr., is credited with bringing the game to this country. With the help of such wealthy friends as William Jay, William Douglas, Perry Belmont, and W. K. Thorne, he transported ponies from Texas to New York City and, in the winter of 1876, staged the first polo game in America at the Dichel Riding Academy.[11] Soon afterward, Bennett's novice polo players displayed their unpolished skills before an affluent racing crowd at New York City's Jerome Park.[12] Exclusive clubs, among them the Westchester Polo Club and the New York Polo Club (which brought the sport to the attention of the summer residents of Newport), soon followed. On August 25, 1886, the first international polo match in America took place, appropriately, in Newport.

In the spring of 1910, when the game was firmly established among the elite, George Bellows painted *Polo at Lakewood*. His patron, Joseph Thomas, had arranged for Bellows to spend a few days at the estate of George Jay Gould in Lakewood, New Jersey.[13] While there, Bellows, who had a marked interest in masculine sports, was intrigued by the speed and power of the ponies and by the dexterity of the riders. He was also impressed with the elegance of the spectators, and he captured in his painting the dramatic and dignified action he had witnessed.

About the same time polo was first gaining popularity in America in the 1870s, coaching became another favorite pursuit of wealthy gentlemen. Anglophiles began importing "four-in-hand" coaches, referred to as "drags," which were "costly private versions of the obsolete British stagecoach."[14] The astounding cost of acquiring a drag and maintaining it made coaching the most elite of all sporting activities. One old coaching enthusiast even proclaimed it

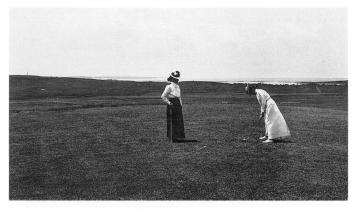

Hal B. Fullerton, MISS BEATRICE HOYT, CHAMPION,
SHINNECOCK GOLF COURSE, 1901
Suffolk County Historical Society.

to be "the acme of social achievement." The same source informed social climbers that the proper term for a four-in-hand coach was a "tally-ho" but cautioned that anyone who referred to it as that rather than a "drag" would easily be recognized as a "parvenu."[15]

A view of a fashionable New York coaching event is provided in the photograph *The Line Up at Claremont — Parade of the Coaching Club,* of 1909. Thomas Eakins's painting *The Fairman Rogers' Four-in-Hand,* of 1879, is an earlier and more detailed study of a drag owned by a wealthy Philadelphian. In this work Eakins portrayed his friend Fairman Rogers, a prominent civil engineer and an avid coachman, seated up front with his wife beside him. Behind them are Mrs. Rogers's brother and sister and their respective spouses, as well as two grooms.[16]

Other gentlemanly sports that were considerably less costly than polo or coaching included rowing, fencing, and angling. In another painting by Thomas Eakins, *Biglin Brothers Turning the Stake,* of 1873, the artist depicted two professional oarsmen from New York, John and Bernard Biglin. The Eakins scholar Lloyd Goodrich stated that this painting was probably based on an actual race that took place on the Schuylkill River in May 1872. Describing the event, Goodrich noted: "The Biglins, wearing blue, have just turned their stake with a blue flag, while their competitors, wearing red, have not yet reached their red flag. In the left distance Eakins himself is seen in the stake boat, signalling with raised arm."[17]

Fencing, an ancient art revived in France in the sixteenth century, became a favorite sport in nineteenth-century America. Like rowing, it was considered to be both a healthful and a genteel activity, with its benefits enumerated in a contemporary account: "erect carriage, grace of gait and correctness of bearing, of good spirits and of courtesy."[18] All of these traits are evident or implied in Gari Melchers's painting *The Fencer,* of around 1895. In the bold, dignified bearing of this man, Melchers has portrayed a vital and potent image of masculinity, without sacrificing the grace demanded by the sport. In fact, gentlewomen were advised to take up fencing as well, and actresses reportedly "always used the exercise for learning how to plant and move their feet intelligently." According to one published account in the *Century* in 1887, "Ladies in the best ranks of life fence more and more as they discover its value for health and good looks."[19]

Women were also encouraged to go on hiking excursions in the mountains, as seen in Winslow Homer's painting *In the Mountains,* of 1877. Articles such as "Adirondack Days," published in *Harper's* in 1881, praised the healthful atmosphere of summer in the mountains, where "there is a sense of freedom and freshness in every hour, the wretched cares and complications of our artificial existence, the strifes and rivalries and hypocr[is]ies of society, are far away and forgotten."[20] What the writer failed to mention is that the societal shackles of women's corsets and bustles were not "far away and forgotten"; despite their inappropriateness, they were still a requisite of the genteel woman's dress code as she devotedly joined her family in hiking, fishing, horseback riding, and playing tennis. Sailing, however, proved impossible with such bulky, confining garments — and from this sporting activity she was therefore excused. The formation of such organizations as the Appalachian Mountain Club, founded in 1876, and the Sierra Club, established in 1892, reflects the appeal of the wilderness for the leisure class.

Fishing clubs were popular among men as well and were rapidly spreading across the country in the 1870s. In the East they were generally formed by city dwellers who regularly made trips to favorite streams, rivers, and lakes in the mountains. The making of "flies" as lures and the art of fly casting were considered to be proper gentlemanly pursuits. Although commercially made flies were available (as was live bait), one avid sportswriter of the period advised that "he who ties his own flies and makes his own rods and tackle will have a keener personal interest in his pastime and give it an additional pleasure which he may enjoy in the long winter evenings when the weary man craves a light amusement."[21] Perhaps Mr. Whitehead, in Ellen Emmet Rand's *Portrait of Oothout Zabriskie Whitehead,* of 1906, is engaged in this pastime. Tournaments held in city parks, such as New York's Central Park, allowed fly-casters to demonstrate their skill. Some witty critics even claimed that technique was an end in itself and that the catching of fish was only a secondary concern. One sarcastic writer commented, "It is extraordinary with what contempt your true angler looks upon any method which will really catch a fish."[22] But one must be reminded that the gentleman angler was not after food for the table: "The love of the art must be above the greed of the prey," as one sporting enthusiast explained.[23]

Recreation, whether an entire summer at a fashionable mountain lodge or a vigorous jaunt on a bicycle in a city park, became an important part of the lives of an increasing number of Americans by the turn of the century. The variety of activities available was limited only by the time and money one could expend on them.

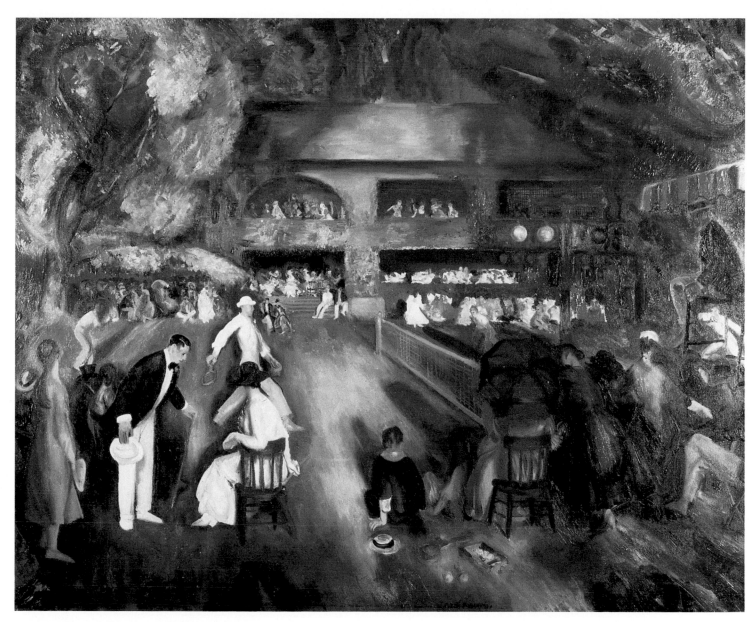

George Bellows, TENNIS AT NEWPORT, 1920
oil on canvas, 57 × 63 inches, Private Collection, United States.

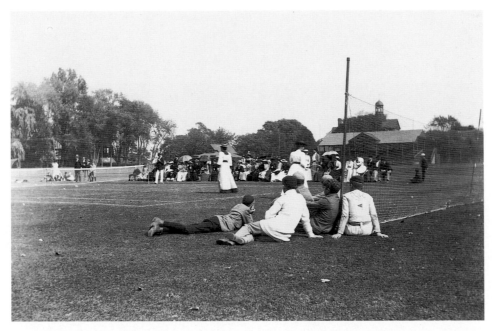

Alice Austen, THE FINALS, BOYS IN FOREGROUND, STATEN ISLAND LADIES CLUB, 1892
Staten Island Historical Society.

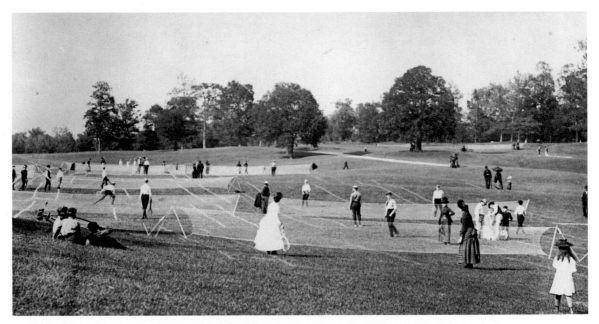

Theodore Gubelman, "LAWN TENNIS" AT PROSPECT PARK, BROOKLYN, NEW YORK
Brooklyn Historical Society.

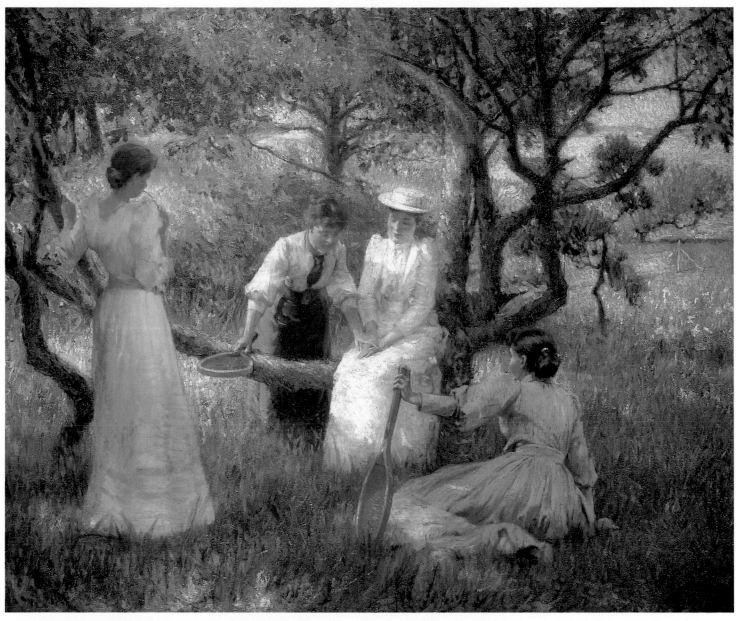

Robert Vonnoh, THE RING, 1892
oil on canvas, 59 × 70¾ inches, Museo de Arte de Ponce, Puerto Rico (Luis A. Ferré Foundation).
Gift of the Banco de Ponce.

Ellen Emmet Rand, PORTRAIT OF OOTHOUT
ZABRISKIE WHITEHEAD, 1906 , oil on canvas,
91½ × 37½ inches, Collection of The Newark Museum.

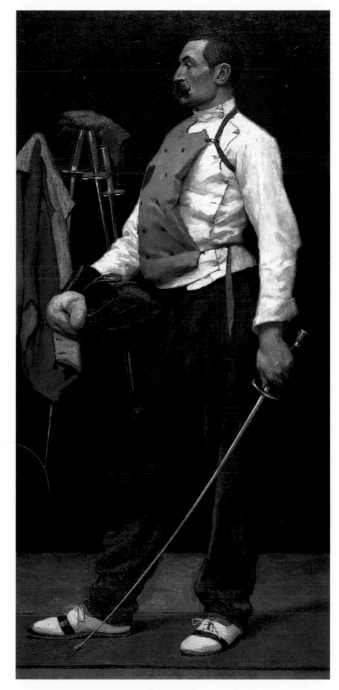

Gari Melchers, THE FENCER, ca. 1895
oil on canvas, 80⅞ × 39¼ inches, Belmont,
The Gari Melchers Memorial Gallery, Mary Washington College,
Fredericksburg, Virginia.

General DeWitt Clinton Falls, THE LINE UP AT CLAREMONT,
PARADE OF THE COACHING CLUB, 1909
Photography Collection, Miriam and Ira D. Wallach Division of Art Prints and Photographs,
The New York Public Library, Astor, Lenox and Tilden Foundations.

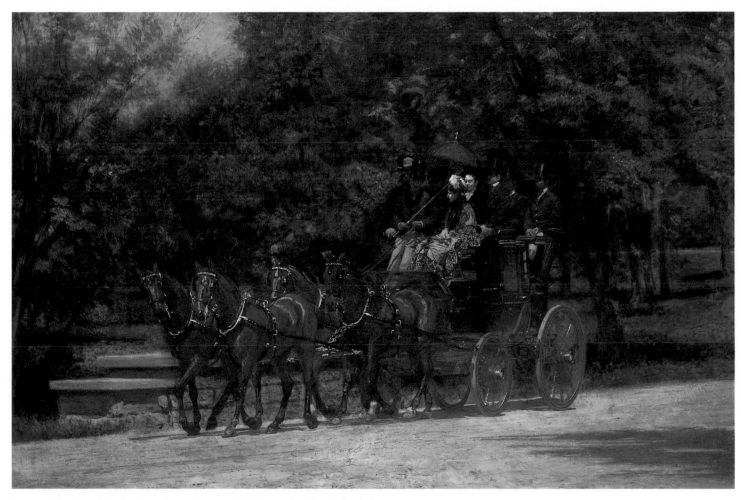

Thomas Eakins, THE FAIRMAN ROGERS' FOUR-IN-HAND, 1879–1880
oil on canvas, 23¾ × 36 inches, Philadelphia Museum of Art.

Otto M. Jones, A POLO GAME, PORTLAND OREGON, ca. 1915
Library of Congress.

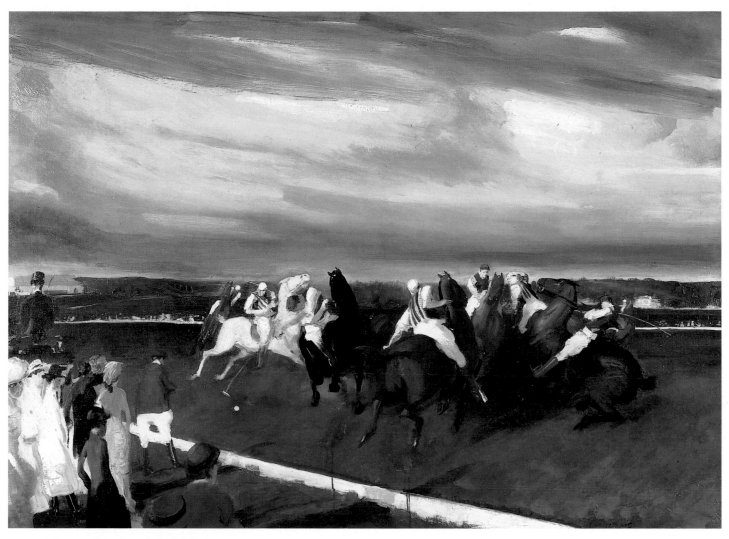

George Bellows, POLO AT LAKEWOOD, 1910
oil on canvas, 45¼ × 63½ inches, Columbus Museum of Art, Ohio. Columbus Art Association Purchase.

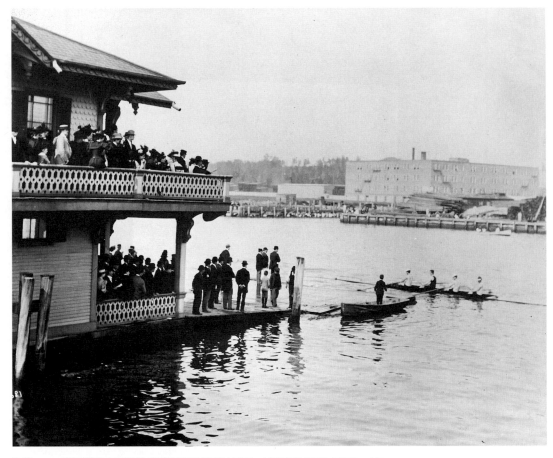

J. Byron, HARLEM RIVER ROWING REGATTA, NEW YORK CITY, 1895
The Byron Collection, Museum of the City of New York.

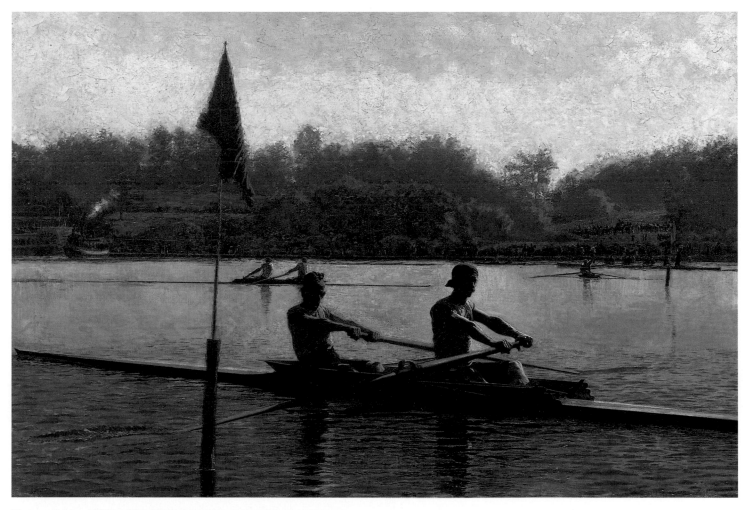

Thomas Eakins, BIGLIN BROTHERS TURNING THE STAKE, 1873
oil on canvas, 40¼ × 60¼ inches, The Cleveland Museum of Art, Hinman B. Hurlbut Collection.

General DeWitt Clinton Falls, ON THE SUMMIT, PIANO MOUNTAIN, LAKE MONHEGAN, 1906
Photography Collection, Miriam and Ira D. Wallach Division of Art Prints and Photographs,
The New York Public Library, Astor, Lenox and Tilden Foundations.

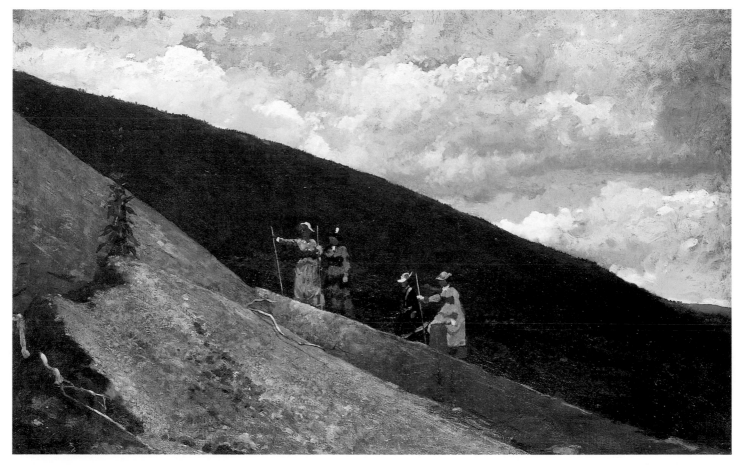

Winslow Homer, IN THE MOUNTAINS, 1877
oil on canvas, 24 × 38 inches, The Brooklyn Museum, 32.1648, Dick S. Ramsay Fund.

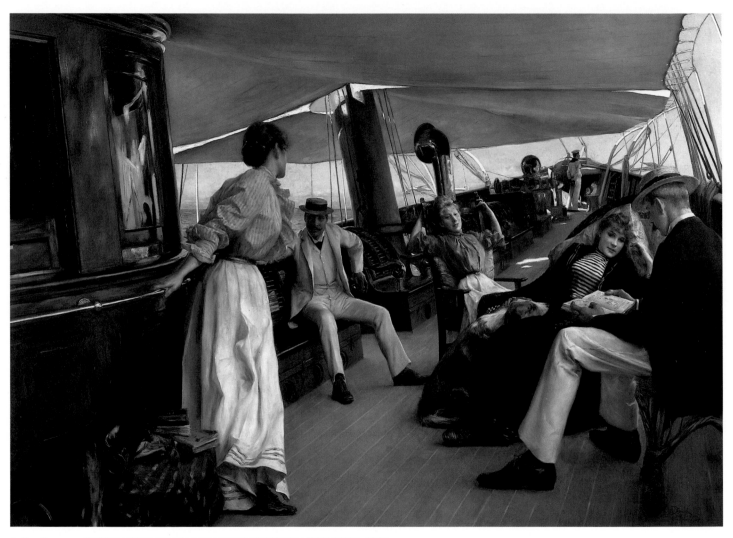

Julius Stewart, THE YACHT "NAMOUNA" IN VENETIAN WATERS, 1890
oil on canvas, 56 × 77 inches, Wadsworth Atheneum, Hartford, Connecticut,
The Ella Gallup Sumner and Mary Catlin Sumner Collection.

Americans Abroad

The Centennial Exposition, held in Philadelphia in 1876, introduced many Americans to the cultural achievements of other lands and was, along with this country's growing prosperity, a motivation for transatlantic travel in subsequent years. The extent of this travel was noted by a writer for *Scribner's,* who reported that in 1881 just over fifty thousand cabin passengers returning from abroad were disembarked in New York City alone.[1] The number soared in 1889, when nearly ninety-seven thousand Americans were drawn to Europe, mainly by the Paris Exposition. This marked increase, however, could not be attributed solely to one event. As a contemporary travel agent commented, "It doesn't need an Exposition in Paris to induce travel. Europe is the lodestone."[2] And its powerful magnetic attraction lured more and more leisure-class Americans each year. The number had been growing annually since 1881 and continued to do so even after the exposition.

By the 1890s the speed with which most steamships could traverse the Atlantic had improved so dramatically that the emphasis shifted from rapidity to luxury. "The traveler of today demands more than comfort and safety," one writer explained. "Traveling is in the main itself a luxury, and as more Americans have found themselves with sufficient means to indulge in it, they have demanded more and more luxurious surroundings and appointments."[3] Steamship companies were quick to meet the demand, furnishing their passengers with opulent accommodations and modern conveniences often surpassing those they were accustomed to in their own homes.

American "colonies" were formed in such cities as London and Paris, as many travelers chose to stay on for long periods of time, some remaining as expatriates until the onset of World War I. For some, the English gentry provided the model; their ultimate goal was to be presented at court in London or, for the wealthiest of debutantes, to marry royalty.

Other leisure-class Americans were attracted to France, most notably Paris, the center of art and high fashion. Although surpassed in numbers by the American expatriates in London, the colony in Paris was still substantial, consisting of "between two and three thousand members"

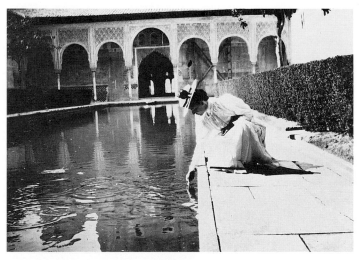

General DeWitt Clinton Falls, FEEDING FISH (THE ALHAMBRA), 1906
Photography Collection, Miriam and Ira D. Wallach Division of
Art Prints and Photographs,
The New York Public Library, Astor, Lenox and Tilden Foundations.

and described as "a little city within a big one — having its own social cliques and customs, its charities, clubs, churches, shops and pensions."[4]

Besides being proof of prosperity, a trip to the continent was considered a mandatory social necessity for those aspiring to the standards of the elite. If one's expenditures were moderate, a journey of one hundred days cost "a thousand dollars for ordinary living and traveling expenses."[5] Frugality, however, was not a characteristic trait of the leisure class. European merchants were more than accommodating, supplying wealthy Americans with emblems of aristocracy, from old-world treasures to modern fashion. American millionaires plundered the continent to form large art collections, while members of the leisure class satisfied themselves with less expensive paintings, objets d'art, decorative furnishings, and curiosities destined for their newly built homes. Wealthy American women with an eye for fashion sought out the best couturiers of Paris, while those less affluent or more conservative engaged the services of French dressmakers. The grand sum of money spent by Americans in foreign cities during this period is astounding. In 1892 the estimated annual expenditure was reported to be more than one hundred million dollars.[6]

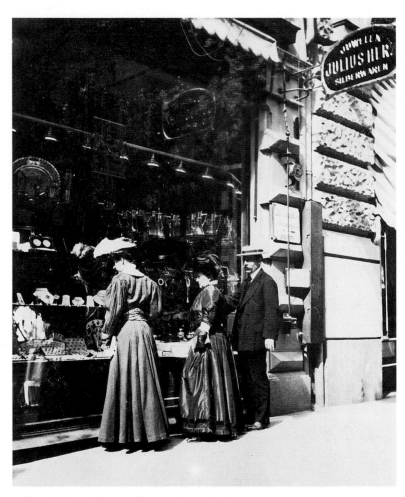

General DeWitt Clinton Falls, SHOPPING (FRANKFURT), 1906
Photography Collection, Miriam and Ira D. Wallach Division of Art Prints and Photographs, The New York Public Library, Astor, Lenox and Tilden Foundations.

More serious concerns motivated young American art students to travel abroad, the majority of them choosing Paris as their destination. Parisian art schools such as the Académie Julian were considered to be among the best in the world, and success at the annual Paris Salon exhibitions could mark the turning point in any artist's career. The students' gathering place was the Art Students Association in the Latin Quarter.[7] A view of typical Parisian studio life is provided by Arthur Mathews in his *Paris Studio Interior,* of about 1887. In this work Mathews has depicted the artistic nature of the studio setting, as three young women, presumably fellow art students, study some prints, while over their heads hangs Mathews's own painting *Imogen and Arviragus,* one of his earliest entries to the Paris Salon.[8]

Like Mathews, William Thorne and Childe Hassam visited Paris in the 1880s and enrolled in the classes of the Académie Julian. The art they created while in Paris focused more directly on the leisurely pursuits of genteel men and women. In his painting *Tête à Tête,* of 1891, Thorne portrays a refined young couple whose leisure-class status is indicated not only by their fine clothing and graceful setting but by the tennis racket placed casually on the floor. Their clothing, conforming to the dictates of the genteel set, is intended not only to look "expensive, but . . . also [to] make plain to all observers that the wearer is not engaged in any kind of productive labour."[9] The high social stature of the elegant people depicted in Hassam's pastel *Au Grand Prix de Paris,* of 1887, is even more emphatic, as evidenced by their fashionable attire. Gentlewomen, as described by Thorstein Veblen, wore corsets, "lowering the subject's vitality and rendering her permanently and obviously unfit for work"; bonnets, similarly making work impossible; and French heels, making "even the simplest and most necessary manual work extremely difficult."[10] Furthermore, elaborate and expensive dresses also served to hamper the wearer at every turn. The gentleman's style of dress is similarly described: "Much of the charm that invests the patent-leather shoe, the stainless linen, the lustrous cylindrical hat, and the walking stick, which so greatly enhance the native dignity of a gentleman, comes of their pointedly suggesting that the wearer cannot when so attired bear a hand in any employment that is directly or immediately of any human use."[11] Unlike women, who had to suffer the restraints of corsets, mature leisure-class men could acceptably be "portly," a condition associated with "opulence" and "personal beauty," as well as a sure sign of "dignified bearing."[12]

The people portrayed in Hassam's pastel clearly adhere to this prescribed dress code as they attend what was considered to be one of the major Parisian social events of the year, the Grand Prix horse race. "The long grandstand with human beings showing from the lowest steps to the sky-line; the green track, and the miles of carriages and coaches encamped on the other side," all made for an impressive sight.[13]

Although most American artists who studied in Paris eventually returned to the United States to pursue their careers, others remained abroad, working as expatriate painters. Among the best known today are John Singer Sargent, James McNeill Whistler, and Mary Cassatt. All came from well-to-do backgrounds, and all, to one degree or another, focused on leisure-class themes and activities, often enlisting their own friends and family members as models. Sargent, the favorite society portraitist of the day, traveled with family and friends during summer months, creating what one family member referred to as his "painted diaries."[14] Whistler, whose contentious personality and laborious technique surely limited the number of friends who were willing to sit for him, managed to prevail upon family members at times. The most familiar of these efforts, of course, is his *Arrangement in Grey and Black: Portrait of the Painter's Mother,* of 1871. A less well known but similarly refined family portrait from Whistler's early period is his painting *At the Piano,* of 1859. In this work the artist used his half-sister, Deborah Delano Whistler (Mrs. Francis Seymour Haden), and her daughter, Annie Haden, as models.[15]

Mary Cassatt, the genteel lady from Philadelphia who became an expatriate painter associated with the French Impressionists, chose equally cultivated themes and subjects for her paintings and pastels. In her painting *The Loge,* of 1882, she depicted two of her friends, Geneviève Mallarmé and Mary Ellison, engaged in a popular leisure-class pastime — attending the opera.[16] The sumptuous decor of the Paris Opera House, which was rebuilt on the Place de l'Opéra in 1875 after several previous structures had been destroyed by fire, generated some controversy. One critic considered the decorative scheme to be "irredeemable": "What would, and should, have been a beautiful pearl-oyster outline of the balcony and tiers of boxes," he complained, "is broken up by bulging curves and re-entering angles. If anything so huge as this sweep of balcony could be made to look weak and puny, these curves would do it; as it is, it only looks clumsy and ugly.

The ornamental detail work is as bad as possible."[17] Even worse than this visual assault, in his estimation, were the acoustics, which resulted in music that sounded "dull and lifeless."[18]

Cassatt's painting portrays two demure young women who are presumably intent on the performance; one of them shyly conceals her expression from any onlookers with her fan. In this composition Cassatt cleverly incorporated the undulating curves of the tiers of boxes to complement the graceful feminine curves of one of her models' shoulders and the sweeping expanse of the other girl's fan.

For those interested in glimpsing social celebrities, there were simpler and less expensive means than going to the opera — cafés were the perfect places to watch and be seen. In fact, the Café de la Paix, jutting out into the Avenue de l'Opéra and the Boulevard des Italiens, was highly recommended as a place where you could sit "at the exact centre of the world and . . . watch it revolve around you." From this vantage point one could visually encompass "the square in front of the Opera House, the boulevard itself, and the three great streets running into it from the river," and as the same writer promised, "if you sit there long enough you will see every one worth seeing in the world."[19] Cafés also served as popular places for idly passing time. In Ferdinand Lungren's painting *The Café,*

of around 1890, a solitary figure is rather rigidly posed in a café that is nearly empty. Here the artist has presented another side of café life, a lonely image when contrasted with the animated atmosphere usually associated with these Parisian establishments.

During the summer and early fall, John Singer Sargent left London to escape the pressures of his portrait commissions. He traveled extensively, with a troop of family and friends, a plentiful supply of reading material, and chests full of costumes, in which his entourage were obliged to bedeck themselves to pose for his paintings. As a cousin of Sargent's explained, "Other travelers wrote their diaries; he painted his, and his sisters, his nieces and nephews, Miss Wedgewood, . . . the Misses Barnard, Mr. and Mrs. de Glehn, Mr. Harrison are all on its pages. Palestine, the Dolomites, Corfu, Italy, Spain, Portugal, Turkey, Norway, Greece, Egypt, France, and the Balearic Islands are on record."[20]

In 1908 Sargent and his group traveled to Majorca, off the eastern coast of Spain, where he painted *Gathering Blossoms at Valdemosa.* Two young children, probably Sargent's nieces, are portrayed gathering the petals of flowers, perhaps to be used in a potpourri.

The following year Sargent traveled to Corfu with Jane and Wilfred de Glehn, fellow artists. The daily schedule

WILLIAM MERRITT CHASE
AND JAMES MCNEILL WHISTLER
IN LONDON, ca. 1885
The William Merritt Chase Archives,
The Parrish Art Museum, Southampton, New York.

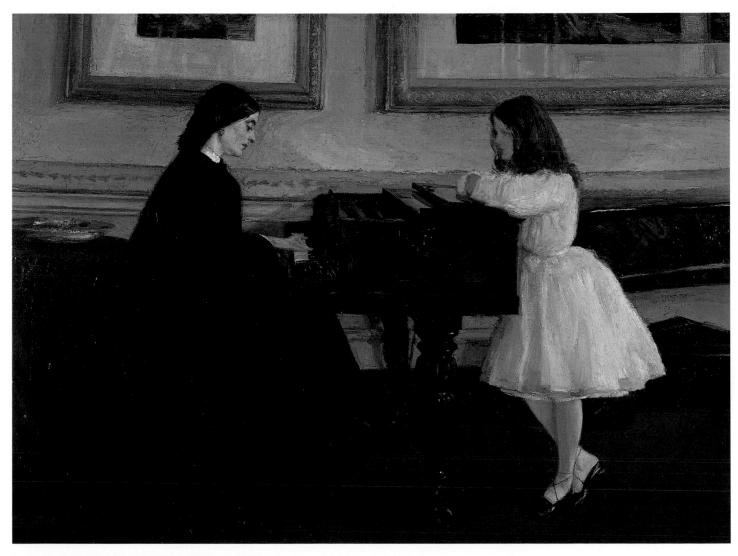

James McNeill Whistler, AT THE PIANO, ca. 1859
oil on canvas, 26⅜ × 36¹/₁₆ inches, The Taft Museum, Cincinnati, Ohio, Bequest of Mrs. Louise Taft Semple.

for these trips was recorded by Miss Eliza Wedgewood, another friend of Sargent's: "Every autumn we spent together the routine was the same — breakfast generally 7:30, afterwards work literally all day till the light failed. At rare intervals an excursion — if very hot a siesta after the midday meal . . . After dinner [piano] duets and chess & early to bed."[21]

Jane de Glehn, aside from being an artist, was credited with being a gifted amateur pianist. In *Jane de Glehn in Corfu (In a Garden at Corfu),* however, Sargent chose to portray his friend not as a painter or as a pianist but engaged in another leisure-class activity, reading—his own favorite pastime. As Miss Wedgewood attested, "Everyone packed books . . . but no one traveled with more than Sargent; reading was one of the most important features in the pattern of his days, abroad or at home."[22]

Although Sargent painted most of his subject pictures while on trips, there are a few notable exceptions, including *In the Luxembourg Gardens,* of 1879. The beauty of this park was described in a contemporary account: "at the end of the Luxembourg Gardens . . . are four lines of horse-chestnuts, with grass, flowers, statues, marble vases, marble pillars between them, all the walks animated by people seated, by people walking, by children at play . . . an ever-changing, revolving kaleidoscope, all these sights, together with Carpeaux's fountain, madly tossing torrents of water in every direction til they break in silver spray, make this scene one of the prettiest in Paris."[23] Diverging from this animated description, Sargent chose to portray the park at twilight, a more serene time of day, when a couple could take a leisurely stroll undisturbed by daytime distractions.[24]

During the day, the Luxembourg Gardens served as a playground for young children, as in Carl Blenner's delightful rendition *Luxembourg Gardens, Paris,* of around 1890. Blenner spent at least six years in Paris, studying at the Académie Julian and exhibiting his paintings at the Paris Salon in the late 1880s and early 1890s. This scene depicts a popular sporting activity of young boys — sailing miniature yachts. Undoubtedly some of these youths actually aspired to taking part in the gentlemanly sport of yachting later in life, but few were privileged to have that opportunity, since it was attainable by only the uppermost level of society.

One of the most colorful yachtsman of the period was James Gordon Bennett, Jr., a dapper bon vivant who maintained several homes in France and in his native America.[25] With the seven million dollars he inherited he was able to entertain lavishly at these homes and on his steam yacht, the *Namouna.* Built in 1881, the *Namouna* was the largest and most luxurious private yacht in existence. Nearly 227 feet long, it sported nine staterooms, a main dining hall, a ladies' saloon, and a number of offices and passageways (as well as quarters for a crew of forty). Louis Comfort Tiffany, representing Associated Artists, decorated much of the interior, which was designed by the prestigious architectural firm of McKim, Mead and White.[26]

Julius Stewart, an American expatriate painter who lived in Paris and specialized in painting society portraits and social events, became a close friend of Bennett's and joined him on his celebrated yacht on several occasions. In Stewart's painting *The Yacht "Namouna" in Venetian Waters,* of 1890, he focused on the life-style of the leisure class rather than on the elaborate appointments of the yacht's interior. The languid, carefree attitude of the wealthy socialites on deck, sheltered from the sun by an awning, clearly reflects their special station in life. The woman seen seated on the right, wearing a striped blouse and patting a dog, has been identified as the popular English actress Lillie Langtry, who has the playboy-sportsman Frederic Gebhard at her side, with Bennett nearby.[27]

Unsurpassed by any American other than Sargent in terms of critical acclaim in the official Paris Salon exhibitions, Stewart came from a wealthy family that moved from Philadelphia to Paris shortly after the Civil War. There they lived comfortably on the profits made by his father's sugar plantation in Cuba. In Paris the young artist was provided with cultivated surroundings. His father collected the paintings of contemporary Spanish artists exhibiting at the Paris Salon, and these paintings greatly influenced Stewart's own dashing style, which was well suited to capturing the sheen of expensive fabrics and the brilliance of fine jewels.[28] The conspicuously social Bennett and the immensely successful expatriate painter made natural companions as they joined in celebrating the good life of the social elite. Their relationship and milieu are recorded for posterity in yet another painting by Stewart, which depicts Bennett and his friends in a typically genteel setting, on an outing near his home in suburban Paris. *On the Banks of the Seine at Bougival,* of 1886, is a perfect example of high-society genre painting, similar to the work of Alfred Stevens and James Jacques Tissot, Stewart's European counterparts.

Julius Stewart, ON THE BANKS OF THE SEINE AT BOUGIVAL, 1886
oil on canvas, 29½ × 48 inches, Private Collection.

Arthur Frank Mathews, PARIS STUDIO INTERIOR, ca. 1887
oil on canvasboard, 20 × 24 inches, The Oakland Museum, gift of the Concours d'Antiques.

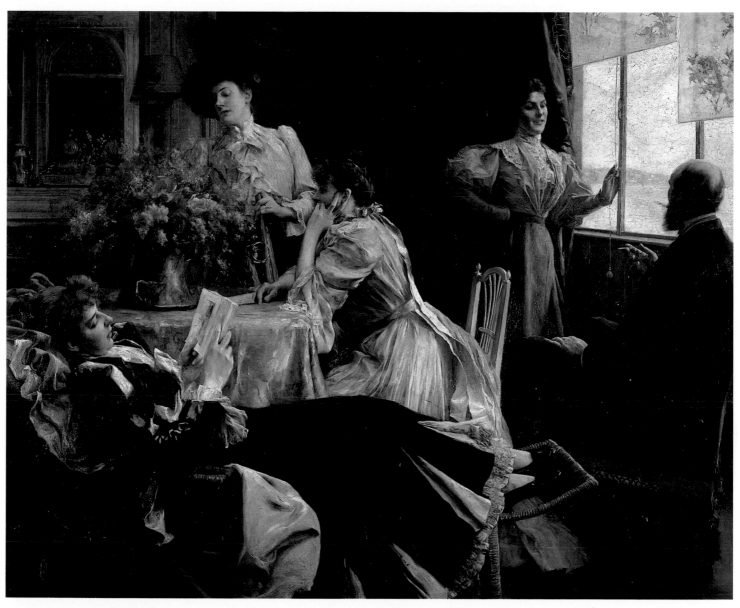

Julius Stewart, INTIMATE, 1897
oil on panel, 31⅜ × 39⅜ inches, Telfair Academy of Arts and Sciences, Savannah, Georgia; Bequest of the Artist.

Ferdinand Lungren, THE CAFE, ca. 1890
oil on canvas, 31⅜ × 41¼ inches, © 1988 The Art Institute of Chicago, Charles H. and Mary Worcester Collection, 1947.85. All Rights Reserved.

William Thorne, TÊTE À TÊTE, 1891
oil on canvas, 40½ × 26½ inches, National Academy of Design, New York.

Carl Blenner, LUXEMBOURG GARDENS, PARIS, ca. 1890
oil on board, 10½ × 13½ inches, Collection Jean-Pierre and Barbara Guillaume.

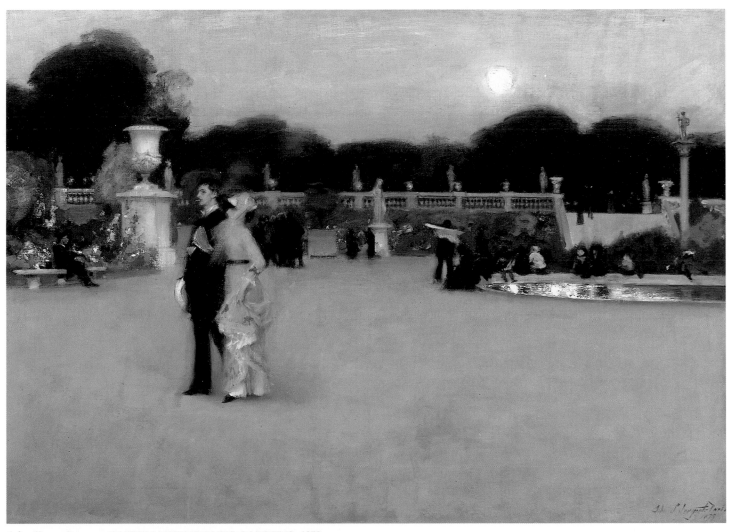

John Singer Sargent, IN THE LUXEMBOURG GARDENS, 1879
oil on canvas, 25½ × 36 inches, John G. Johnson Collection, Philadelphia.

STAIRCASE AT THE PARIS OPERA, ca.1875
Billy Rose Theatre Collection, The New York Public Library at Lincoln Center,
Astor, Lenox and Tilden Foundations.

Mary Cassatt, THE LOGE, 1882
oil on canvas, 31½ × 25⅛ inches, National Gallery of Art, Washington, D.C., Chester Dale Collection.

Edward Steichen, STEEPLECHASE DAY, THE GRANDSTAND, 1907
Collection The Metropolitan Museum of Art, Gift of Alfred G. Stieglitz, 1933. (33.43.49)

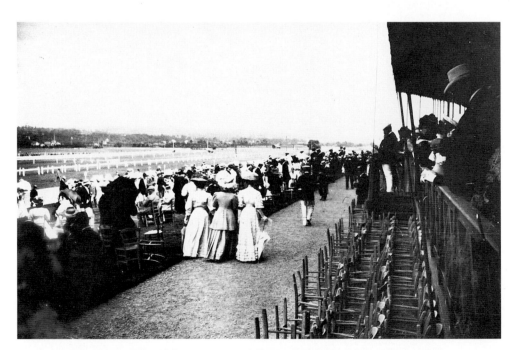

General DeWitt Clinton Falls, THE STAND, THE RACE COURSE, DEAUVILLE, 1907
Photography Collection, Miriam and Ira D. Wallach Division of Art Prints and Photographs,
The New York Public Library, Astor, Lenox and Tilden Foundations.

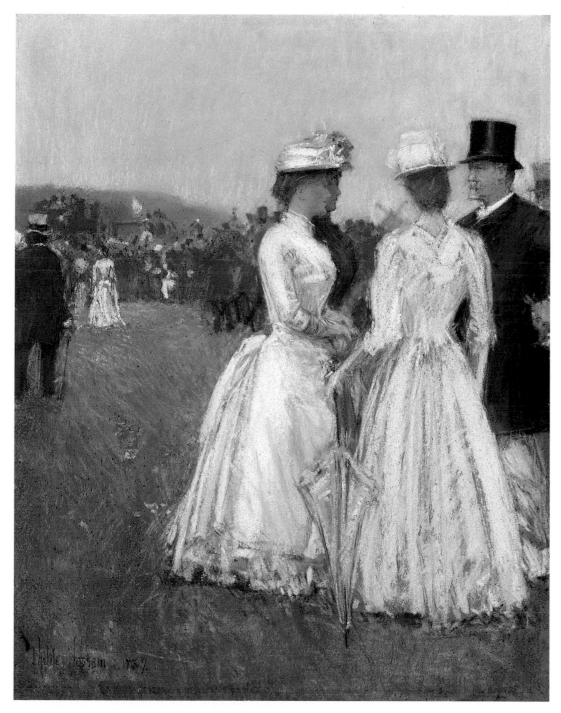

Frederick Childe Hassam, AU GRAND PRIX DE PARIS, 1887
pastel on paper, 18 × 12 inches, The Corcoran Gallery of Art, Bequest of James Parmelee.

Clarence White, IN THE ORCHARD, NEWARK, OHIO, 1902
Collection The Museum of Modern Art, New York. Gift of Jane Felix White.

John Singer Sargent, GATHERING BLOSSOMS AT VALDEMOSA, 1908
oil on canvas, 28 × 22 inches, Collection Kathryn and Robert Steinberg.

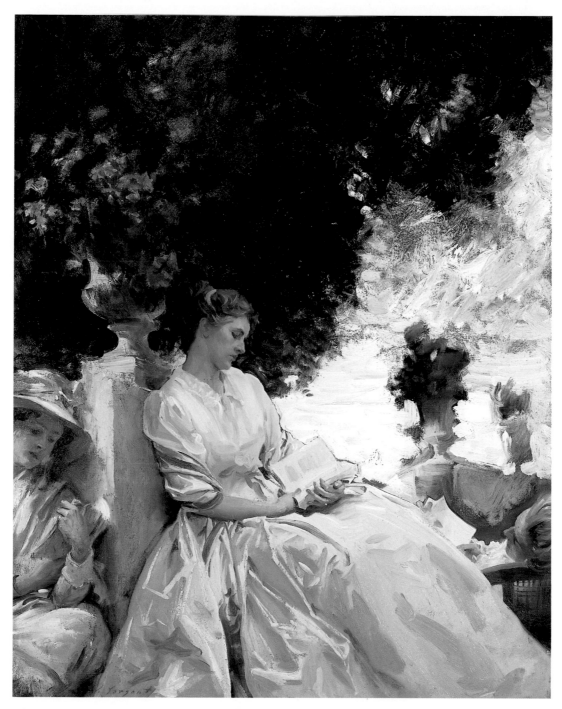

John Singer Sargent, JANE DE GLEHN IN CORFU (IN A GARDEN AT CORFU), 1909
oil on canvas, 36 × 28 inches, Daniel J. Terra Collection, Terra Museum of American Art, Chicago, Illinois.

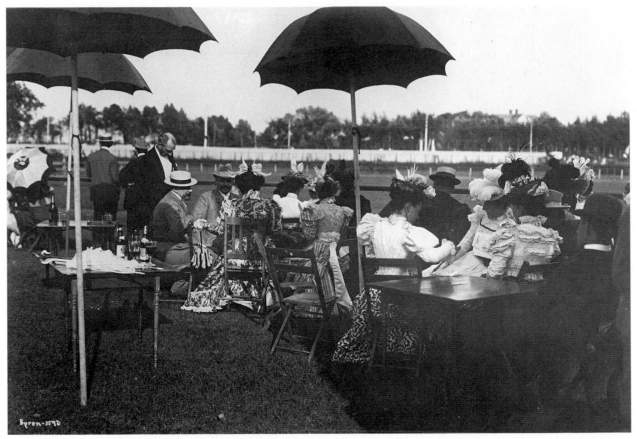

J. Byron, "THE ELITE," HORSESHOW AT HOLLYWOOD, MONMOUTH PARK,
NEW JERSEY, AUGUST, ca. 1895–1896
The Byron Collection, Museum of the City of New York.

Afterword
Acknowledgements

In compiling this book, I soon realized that there were innumerable images of leisure-class activities from which to choose. This meant setting strict guidelines for the limited number of works that could be represented. Since this book focuses mainly on painting, aesthetic consideration was given priority over a comprehensive representation of activities in the selection process. Early on I decided that only fine art (rather than book and periodical illustrations) would be used. My next concern was in balancing the use of "fresh" or little-known paintings with those that are well known but particularly appropriate to each theme. Since the quality of the work was the criterion for inclusion, some leisure-class activities are represented by multiple images while others are not represented at all; some important painters of the day are represented by only one painting (or none at all) while others are represented by many images. This can be explained by the fact that some artists made the life of leisure-class Americans their major theme, and others treated it peripherally. Also, the idyllic images produced by artists associated with the American Renaissance have for the most part been excluded. Their treatment of related subjects seemed too ethereal, lacking the vitality and directness of the work of those artists presented in the book, who best captured the spirit of America's leisure class during the gilded age. Finally, the photographs selected were intended primarily to complement the paintings reproduced, and at times to supplement those images. Again, both well-known photographs by professional photographers and little-known images have been combined, with a concern for balance as well as for variety. The process was a lengthy and involved task, but a most rewarding one, and I am indebted to the many people who offered valuable assistance.

I would like to thank those who answered special questions and directed me to works appropriate for use as illustrations in the book. For help on specific artists I am grateful for the expertise of the following individuals: Warren Adelson and Donna Seldin (John Singer Sargent); Doreen Bolger Burke (J. Alden Weir); Kathleen Burnside (Childe Hassam); Johanna D. Catron (Gari Melchers); Carol Clark and Carol Derby (Maurice Prendergast); Susan Hobbs (Thomas Dewing); Gary Reynolds (Irving Wiles); Beverly Rood (J. Carroll Beckwith); and Bruce Weber (Robert Blum). I am especially grateful for the assistance of Edward Shein. Others who were particularly helpful in the selection of images for the book include Jane Hankins, Museum of Fine Arts, Boston; Barbara Krulik, National Academy of Design; Milo Naeve, Art Institute of Chicago; Michael Quick, Los Angeles County Museum of Art; Paul D. Schweizer, Munson-Williams-Proctor Institute; and Judy Sourakli, Henry Art Gallery. Scholars in other areas who have offered me valuable assistance include Susan Fraser, New York Botanical Garden and Heather Hamilton, William Secord, and Roberta Vesley of the Dog Museum of America.

Art dealers and auction houses were especially generous in helping me locate specific paintings and in providing color transparencies for reproduction. Among those who deserve special credit are Vance Jordan, Jordan-Volpe Gallery; Betty Krulik, Christie, Manson and Woods; Susan E. Menconi and Mrs. M. P. Naud, Hirschl & Adler Galleries; Joan Michelman; John E. Parkerson; Andrea Popowich and Mary Ushay, Berry-Hill Galleries; Peter Rathbone and Dara Mitchell, Sotheby's; Ginger Sawyer, Robert W. Skinner Incorporated; and Hollis C. Taggart, Taggart, Jorgenson & Putman.

I would like to thank the staffs of the institutions where I found black-and-white images: The Library of Congress; the Library Company of Philadelphia; and the Museum of Modern Art. Those who were especially helpful deserve to be singled out: Terry Ariano, Museum of the City of New York; Sharon Frost, New York Public Library; and Ellie Reichlin, Society for the Preservation of New England Antiquities.

I would also like to thank the editorial staff of Little, Brown and Company, particularly Thacher Storm, Dorothy Straight, and Christina Holz. I am especially indebted to Ray Roberts for his support, from the initial concept of the book through to its completion.

Finally, I would like to acknowledge the very special help I received from John Esten and Beverly Rood for their professional collaboration in compiling this book. John deserves full credit for the book's design and additional thanks for assisting me in the selection of paintings and photographs. Beverly, my assistant, must be praised and thanked for her efforts in every aspect of the preparation of this book: her comprehensive research, related correspondence, coordination, and organization of all visual materials, writing of footnotes and bibliography, and dealing with all of the rights of reproduction forms and fees. Aside from her diligence in successfully overseeing all of these tasks, I also appreciate her thoughts on aesthetic considerations in selecting the works to be reproduced and her helpful suggestions for improving the text. Most importantly, she is to be commended for her patience and engaging personality, which made this venture a pleasant experience for all involved.

Notes

Introduction
1. Pack, *The Challenge of Leisure*.
2. Veblen, *Theory of the Leisure Class*, 55, 43, 209.
3. "The Point of View," February 1892, 261–262.
4. "The Point of View," June 1892, 789.
5. Repplier, "Leisure," 63, 67.
6. Eggleston, "Americans at Play," 554.
7. Veblen, *Theory of the Leisure Class*, 45.
8. "Woman and Her Work," 634.
9. Harrison, "Nursery Decoration and Hygiene," 470.
10. "The Point of View," July 1893, 132.
11. "Prizes for Decorative Art and Needle-Work," 794.
12. Kenyon Cox, 1911, quoted in David C. Huntington, "The Quest for Unity: American Art Between World's Fairs 1876–1893," in Huntington and Pyne, *The Quest for Unity*, 36.

Entertaining
1. Harvey Green, *The Light of the Home*, 144.
2. Ibid., 144–145.
3. Van Rennselaer, "The Plague of Formal Calls," 787–788.
4. Mrs. John Sherwood, "The Small Talk of Society," in Diamond, *The Nation Transformed*, 304, 305, 307.
5. Veblen, *Theory of the Leisure Class*, 65.
6. Ibid., 155–156.

Lounging Outdoors
1. Church, "Outdoor Parlors," 629.
2. Ibid.
3. Beard and Beard, *How to Amuse Yourself and Others: The American Girls Handy Book*, 159.

Reading
1. "Point of View," November 1893, 659.
2. Veblen, *Theory of the Leisure Class*, 45.
3. "Point of View," November 1893, 650.
4. Jay Martin, *Harvests of Change*, 19.
5. "Point of View," August 1892, 261.
6. William Coffin, "American Illustration of To-Day," *Scribner's Monthly* 11, no. 1 (January 1892): 108.
7. Burke, *American Paintings*, 356.
8. Trachtenberg, *The Incorporation of America*, 186.
9. Cable, *The Little Darlings*, 120.
10. Books by Charles Dudley Warner set in Northeastern summer resorts of the social elite, as well as books by Frank R. Stockton, "the principal humorist of the genteel tradition," were popular reading material. See Smith, *The Popular American Novel*, 66, 78. Etiquette books were considered the "social bible" for women. See Williams, *Savory Suppers*, 17.
11. Burke, *American Paintings*, 418.
12. Furnas, *The Americans*, 608, 610.

A Musical Interlude
1. Thomas, "Musical Possibilities in America," 777.

2. Ibid.
3. Upton, "Musical Societies of the United States," 82.
4. Cook, "Some Old-Fashioned Things Worth Reviving," 147, 148.
5. Ibid., 148.
6. Furnas, *The Americans*, 586.
7. Carson, *The Polite Americans*, 157, 159, 164.
8. Sullivan, *Our Times*, 263.
9. Anthony Burgess, "The Well-Tempered Revolution: A Consideration of the Piano's Social and Intellectual History," in Gaines, *The Lives of the Piano*, 4.

Aestheticism
1. Veblen, *Theory of the Leisure Class*, 54.
2. Ibid., 376.
3. Furnas, *The Americans*, 669.
4. "Society of Decorative Art," 699.
5. Candace Wheeler, *Yesterdays in a Busy Life*, quoted in Marling, "Portrait of the Artist as a Young Woman," 50.
6. Veblen, *Theory of the Leisure Class*, 160.
7. "Art Embroidery," 693.
8. "Marine Forms as Applicable to Decoration," 810–822.
9. Weber, *Robert Frederick Blum*, 219.
10. Furnas, *The Americans*, 668.
11. Ibid., 670.

Flora and Fauna
1. Veblen, *Theory of the Leisure Class*, 179–180.
2. Scourse, *Victorians and Their Flowers*, 11, 96.
3. Emsweller, "The Chrysanthemum," 27, provided by Susan Fraser, Assistant Librarian, New York Botanical Garden.
4. "Popularity of the Chrysanthemum," 491.
5. Parsons, "The Ornamentation of Ponds and Lakes," 355.
6. Ibid.
7. Ibid.
8. June, "The Etiquette of Ladies' Luncheons," 327.
9. Scourse, *Victorians and Their Flowers*, 38.

In the Park
1. Frederick Law Olmsted, "Public Parks and the Enlargement of Towns," 1870, in Trachtenberg, *The Incorporation of America*, 109–110, 146.
2. "Playgrounds and Parks," 221.
3. Reed and Duckworth, *Central Park: A History and a Guide*, 80, points out that the "conservatory" planned for this area was never built.
4. Eleanor Green, *Maurice Prendergast*, 106.

Children's Games
1. Harrison, "American Children," 796; Ehrenreich and English, *For Her Own Good*, 164.
2. Ehrenreich and English, *For Her Own Good*, 167.
3. Harrison, "American Children," 796.
4. Chapman, "Proper Work and Recreation," 261–263.

[5] Bates, *Games Without Music for Children,* v–vi, 54–55.

[6] Bartlett, *Parlor Amusements for the Young Folks,* 19; "A Chapter on Tableaux," 91–103.

[7] Burnett's character is said to have been based on the personality and appearance of her own son, Vivian, born in 1876. See Laski, *Mrs. Ewing, Mrs. Molesworth and Mrs. Hodgson Burnett,* 82.

[8] McClinton, *Antiques of American Childhood,* 224–225.

Pets

[1] Veblen, *Theory of the Leisure Class,* 140.

[2] Routledge, *Every Boy's Book.*

[3] Veblen, *The Theory of the Leisure Class,* 141.

[4] Miller, *Our Home Pets,* 142–143.

[5] Routledge, *Every Boy's Book,* 513.

[6] Miller, *Our Home Pets,* 163.

[7] Routledge, *Every Boy's Book,* 507.

[8] Miller, *Our Home Pets,* 163–65.

[9] Sullivan, *Our Times,* 412. This author notes that the breeds popular at the turn of the century were completely out of fashion by 1925.

[10] William Secord of the Dog Museum of America, New York, assisted us in identifying the breed of dog shown in the Robinson, Chase, and Vonnoh paintings.

[11] Earl, *Pets of the Household,* 94.

[12] Ibid., 95.

[13] Routledge, *Every Boy's Book,* 534–535.

[14] Dorothy Weir Young, *The Life and Letters of J. Alden Weir, cxxxii.*

Holidays by the Water

[1] Greely, "Where Shall We Spend Our Summer?" 481.

[2] Ibid.

[3] Rochard, "Summer Outings in Europe," 711.

[4] Greely, "Where Shall We Spend Our Summer?" 481.

[5] Sherwood, *Etiquette,* 169.

[6] Garland, *Boston's North Shore,* 252–253, 233.

[7] Ibid., 172.

[8] See Caffin, "The Art of Frank W. Benson."

[9] Gordon Hendricks, *The Life and Work of Winslow Homer* (New York: Harry N. Abrams, 1979), 141.

The Sporting Life

[1] Veblen, *The Theory of the Leisure Class,* 160.

[2] Armitage, *Man at Play,* 147.

[3] Routledge, *Every Boy's Book.*

[4] See Curry, *Winslow Homer: The Croquet Game.*

[5] Frederick S. Lightfoot, Linda B. Martin, Bette S. Weidman, *Suffolk County, Long Island, in Early Photographs* (New York: Dover Publications, 1984), 112.

[6] Speed, "Golf," 609.

[7] Garland, *Boston's North Shore,* 246.

[8] Krout, *Annals of American Sport,* 151. Krout and others give the British Army officer Major Walter C. Wingfield credit for introducing to England in the summer of 1873 the game of "sphairistike," adapted from the French version of field tennis played as far back as the Middle Ages.

[9] *The Southampton Press,* July 3, 1897.

[10] "A Wheel Around the Hub," 481.

[11] Krout, *Annals of American Sport,* 274; see pages 274–277 for a history of polo in America.

[12] Furnas, *The Americans,* 607.

[13] Braider, *George Bellows and the Ashcan School of Painting,* 61.

[14] Furnas, *The Americans,* 607.

[15] Quoted in Cable, *Top Drawer,* 153.

[16] Goodrich, *Thomas Eakins,* 1:264.

[17] Ibid., 1:83.

[18] "Fencing and the New York Fencers," *Century Illustrated Monthly Magazine* 33, no. 3 (January 1887): 415.

[19] Ibid., 417.

[20] "Adirondack Days," 687–688.

[21] Yale, "Getting Out the Fly-Books," 32.

[22] Ibid., 28.

[23] Ibid.

Americans Abroad

[1] Gould, "Ocean Passenger Travel," 410.

[2] Ibid., 411.

[3] Ibid., 405.

[4] Ford, "American Society in Paris," 72–73.

[5] Loomis, "Americans Abroad," 678.

[6] Ibid., 678–679.

[7] Ford, "American Society in Paris," 73.

[8] Huntington and Pyne, *Quest for Unity,* 118–119.

[9] Veblen, *Theory of the Leisure Class,* 170.

[10] Ibid., 171–172.

[11] Ibid., 170–171.

[12] Ibid., 146.

[13] Davis, *About Paris,* 141.

[14] Patricia Hills, " 'Painted Diaries': Sargent's Late Subject Pictures," in Hills et al., *John Singer Sargent,* 195.

[15] Young, MacDonald, Spencer, and Miles, *Paintings of James McNeill Whistler,* 8.

[16] Breeskin, *Mary Cassatt: A Catalogue Raisonné,* 72.

[17] Apthorp, "Paris Theatres and Concerts II," 356.

[18] Ibid., 357.

[19] Davis, "The Streets of Paris," 703–704.

[20] Patricia Hills, " 'Painted Diaries': Sargent's Late Subject Pictures," in Hills et al., *John Singer Sargent,* 195.

[21] Olson, *John Singer Sargent: His Portrait,* 239.

[22] Ibid.

[23] Osborne, "Glimpses of Paris," 74.

[24] Patricia Hills points out that this painting is indebted to the pictorial tradition of the "flaneur" (stroller) developed by Manet and others in the 1860s. See "The Formation of Style and Sensibility," in Hills et al., *John Singer Sargent,* 32.

[25] See Cable, *Top Drawer,* 7–10, and Pyne and Huntington, *The Quest for Unity,* 244–245, for descriptions of Bennett, the yacht *Namouna,* and Julius Stewart's painting.

[26] Benjamin, "Steam-Yachting in America," 603–607.

[27] Pyne and Huntington, *The Quest for Unity,* 245.

[28] See Thompson, "Julius L. Stewart," 1046–1058.

Bibliography

Ackerman, Evelyn. *Dressed for the Country: 1860–1900*. Exh. cat. Los Angeles: Los Angeles County Museum of Art, 1984.

"Adirondack Days." *Harper's New Monthly Magazine* 63, no. 377 (October 1881): 678–693.

Apthorp, William. "Paris Theatres and Concerts II: The Opera, the Opera-Comique, and the Conservatoire." *Scribner's Monthly* 11, no. 3 (March 1892): 350–365.

Armitage, John. *Man at Play: Nine Centuries of Pleasure Making*. London and New York: Frederick Warne, 1977.

"Art Embroidery." *Harper's New Monthly Magazine* 62, no. 371 (April 1881): 693–699.

Bartlett, G. B. *Parlor Amusements for the Young Folks*. New York: Happy Hours Co., 1876.

Bates, Lois. *Games Without Music for Children*. New York and Bombay: Longman's, Green and Co., 1897.

Beard, Lina, and Adelia Beard. *How to Amuse Yourself and Others: The American Girls Handy Book*. New York: Charles Scribner's Sons, 1903.

———. *Handicraft and Recreation for Girls*. New York: Charles Scribner's Sons, 1904.

———. *What a Girl Can Make and Do*. New York: Charles Scribner's Sons, 1906.

Beaux, Cecilia. *Background with Figures*. Boston and New York: Houghton Mifflin Co., 1930.

Benjamin, S. G. W. "Steam-Yachting in America." *Century Magazine* 24, no. 4 (August 1882): 598–607.

Braider, Donald. *George Bellows and the Ashcan School of Painting*. Garden City, N.Y.: Doubleday, 1971.

Breeskin, Adelyn Dohme. *Mary Cassatt: A Catalogue Raisonné of the Oils, Pastels, Watercolors and Drawings*. Washington, D.C.: Smithsonian Institution Press, 1970.

Briggs, Asa, ed. *The Nineteenth Century: The Contradictions of Progress*. New York: McGraw-Hill, 1970.

Brown, Jeffrey. *Alfred Thompson Bricher, 1837–1908*. Exh. cat. Indianapolis, In.: Indianapolis Museum of Art, 1973.

Bruce, Edward C. "Our Flower-Gardens." *Lippincott's Monthly Magazine* 3 (May 1882): 512–518.

Burke, Doreen Bolger. *American Paintings in the Metropolitan Museum of Art*. Edited by Kathleen Luhrs. Volume III. New York: Metropolitan Museum of Art, 1980.

———. *Julian Alden Weir: An American Impressionist*. Newark, Del.: University of Delaware Press, 1983.

Cable, Mary. *The Little Darlings: A History of Child Rearing in America*. New York: Charles Scribner's Sons, 1975.

———. *Top Drawer: American High Society from the Gilded Age to the Roaring Twenties*. New York: Atheneum, 1984.

Caffin, Charles H. "The Art of Frank W. Benson." *Harper's Monthly Magazine* 119 (June 1909): 105–114.

Carson, Gerald. *The Polite Americans*. New York: William Morrow, 1966.

Chadwick, George F. *The Park and the Town: Public Landscape in the Nineteenth and Twentieth Centuries*. New York: Frederick A. Praeger, 1966.

Chapman, Louise. "Proper Work and Recreation for Our Children." *The Cosmopolitan* 1, no. 4 (June 1886): 261–263.

"A Chapter on Tableaux." *Scribner's Monthly* 21, no. 1 (November 1880): 91–103.

"Chrysanthemums at Short Hills, New Jersey." *Garden and Forest* 5 (November 2, 1892): 526–527.

Church, Ella Rodman. "Outdoor Parlors." *Scribner's Monthly* 22, no. 4 (August 1881): 629–630.

Cook, Clarence. "Some Old-Fashioned Things Worth Reviving." *Scribner's Monthly* 22, no. 1 (May 1881): 147–149.

Cranz, Galen. *The Politics of Park Design: A History of Urban Parks in America*. Cambridge, Mass.: MIT Press, 1982.

Curry, David Park. *Winslow Homer: The Croquet Game*. New Haven: Yale University Art Gallery, 1984.

Davis, Richard Harding. "The Streets of Paris." *Harper's New Monthly Magazine* 89, no. 533 (October 1894): 701–712.

———. *About Paris*. New York and London: Harper and Bros., 1904.

Delgado, Alan. *Victorian Entertainment*. New York: American Heritage Press, 1971.

Diamond, Sigmund, ed. *The Nation Transformed*. New York: George Braziller, 1963.

Dreiss, Joseph G. *Gari Melchers: His Works in the Belmont Collection*. Charlottesville, Va.: University Press of Virginia, 1984.

Dwight, James. "Court Tennis." *Scribner's Magazine* 9, no. 1 (January 1891): 99–106.

Earl, Thomas M. *Pets of the Household*. Columbus, Ohio: A. W. Livingston's Sons, 1896.

Eckford, Henry. "Fencing and the New York Fencers." *Century Magazine* 33, no. 3 (January 1887): 414–421.

Eggleston, Edward. "Americans at Play." *Century Magazine* 28, no. 4 (August 1884): 554–556.

Ehrenreich, Barbara, and Deirdre English. *For Her Own Good: 150 Years of the Expert's Advice to Women*. Garden City, N.Y.: Anchor Press, 1978.

Emsweller, S. L. "The Chrysanthemum: Its Story Through the Ages." *New York Botanical Garden Journal* (February 1947).

Ford, Mary Bacon. "American Society in Paris." *The Cosmopolitan* 15, no. 1 (May 1893): 72–79.

Furnas, J. C. *The Americans: A Social History of the United States, 1587–1914*. New York: G. P. Putnam's Sons, 1969.

Gaines, James R., ed. *The Lives of the Piano*. New York: Holt, Rinehart and Winston, 1981.

Garland, Joseph E. *Boston's North Shore*. Boston: Little, Brown and Co., 1978.

Gerdts, William H. *Down Garden Paths: The Floral Environment in American Art*. Cranbury, N.J.: Associated University Presses, 1983.

———. *American Impressionism*. New York: Abbeville Press, 1984.

Goodrich, Lloyd. *Thomas Eakins*. 2 vols. Cambridge, Mass.: Harvard University Press, 1982.

Gould, John H. "Ocean Passenger Travel." *Scribner's Magazine* 9, no. 4 (April 1891): 399–418.

Gray, David. "Polo: The Best Game in the World." *Collier's*, June 10, 1911, 15, 28.

Greely, A. W. "Where Shall We Spend Our Summer?" *Scribner's Magazine* 3, no. 4 (April 1888): 481.

Green, Eleanor. *Maurice Prendergast: Art of Impulse and Color*. Exh. cat. College Park, Md.: University of Maryland Art Gallery, 1976.

Green, Harvey. *The Light of the Home: An Intimate View of the Lives of Women in Victorian America*. New York: Pantheon Books, 1983.

Harrison, Constance Cary. "Home-Decorations — Screens and Portieres." *Scribner's Monthly* 21, no. 1 (November 1880): 155–56.

———. "Nursery Decoration and Hygiene." *Scribner's Monthly* 21, no. 3 (January 1881): 470–472.

———. "American Children at Home and in Society." *Century Magazine* 25, no. 6 (April 1883): 796.

Hawthorne, Julian. "College Boat-Racing." *Century Magazine* 34, no. 2 (June 1887): 176–189.

Hill, May Brawley. "The Early Career of Robert William Vonnoh." *The Magazine Antiques* 80, no. 5 (November 1986): 1014–1023.

Hills, Patricia. *Turn-of-the-Century America: Paintings, Graphics, Photographs, 1890–1910*. Exh. cat. New York: Whitney Museum of American Art, 1977.

Hills, Patricia, Linda Ayres, Annette Blaugrund, Albert Boime, William H. Gerdts, Stanley Olson, and Gary A. Reynolds. *John Singer Sargent*. New York: Whitney Museum of American Art, 1986.

Huneker, John F. "Amateur Rowing." *Lippincott's Monthly Magazine* 51 (June 1893): 712–719.

Huntington, David C., and Kathleen Pyne. *The Quest for Unity: American Art Between World's Fairs, 1876–1893*. Exh. cat. Detroit: Detroit Institute of Arts, 1983.

Johns, Elizabeth. *Thomas Eakins: The Heroism of Modern Life*. Princeton, N.J.: Princeton University Press, 1983.

Johnston, Sona. *Theodore Robinson, 1852–1896*. Exh. cat., Baltimore, Md.: Baltimore Museum of Art, 1973.

June, Jenny. "The Etiquette of Ladies' Luncheons." *The Cosmopolitan* 11, no. 5 (January 1887): 326–329.

Krout, John Allen. "Some Reflections on the Rise of American Sport" (1928). In *The Sporting Set: The Leisure Class in America*. New York: Arno Press, 1975.

———. *Annals of American Sport*. Vol. 15 of *The Pageant of America*. Edited by Ralph Henry Gabriel. New Haven: Yale University Press, 1929.

Laski, Marghanita. *Mrs. Ewing, Mrs. Molesworth and Mrs. Hodgson Burnett*. New York: Oxford University Press, 1951.

"Lawn Tennis." *Century Magazine* 23, no. 4 (April 1882): 628–633.

Lears, T. J. Jackson. *No Place of Grace: Antimodernism and the Transformation of American Culture, 1880–1920*. New York: Pantheon Books, 1981.

Loomis, Francis B. "Americans Abroad." *Lippincott's Monthly Magazine* 53 (May 1894): 678–682.

Lynes, Russell. *The Taste-Makers*. New York: Harper and Bros., 1954.

McClinton, Katherine Morrison. *Antiques of American Childhood*. New York: Clarkson N. Potter, 1970.

"Marine Forms as Applicable to Decoration." *Scribner's Monthly* 21, no. 6 (April 1881): 810–822.

Marling, Karal Ann. "Portrait of the Artist as a Young Woman: Miss Dora Wheeler." *The Bulletin of the Cleveland Museum of Art* 65, no. 2 (February 1978): 47–57.

Martin, Frederick Townsend. *The Passing of the Idle Rich*. Garden City, N.Y.: Doubleday, Page and Co., 1911.

Martin, Jay. *Harvests of Change: American Literature, 1865–1914*. Englewood Cliffs, N.J.: Prentice-Hall, 1967.

Miller, Olive Thorne. *Our Home Pets: How to Keep Them Well and Happy*. New York: Harper and Bros., 1894.

Mitchell, J. A. "Types and People at the Fair." *Scribner's Magazine* 14, no. 2 (August 1893).

Mowll, Nancy, ed. *Cassatt and Her Circle: Selected Letters*. New York: Abbeville Press, 1984.

Newell, William Wells. *Games and Songs of American Children Compiled and Compared by William Wells Newell*. New York: Harper and Bros., 1884.

Olson, Stanley. *John Singer Sargent: His Portrait*. New York: St. Martin's Press, 1986.

Osborne, J. D. "Glimpses of Paris." *Century Magazine* 27, no. 1 (November 1883): 74–86.

Pack, Arthur Newton. *The Challenge of Leisure*. Washington, D.C.: McGrath Publishing Co. and National Recreation and Park Association, 1934.

Parsons, Samuel, Jr. "The Ornamentation of Ponds and Lakes." *Scribner's Magazine* 9, no. 3 (March 1891): 351–360.

Pisano, Ronald G. *A Leading Spirit in American Art: William Merritt Chase, 1849–1916*. Seattle: Henry Art Gallery, University of Washington, 1983.

"Playgrounds and Parks." *Garden and Forest* 7 (June 6, 1894): 221–222.

"Point of View." *Scribner's Monthly* 11, no. 2 (February 1892): 261–262; 11, no. 5 (May 1892): 658–659; 11, no. 6 (June 1892): 789; 12, no. 2 (February 1893): 263; 12, no. 2 (August 1892): 261; 14, no. 1 (July 1893): 132; 14, no. 5 (November 1893): 659.

"Popularity of the Chrysanthemum." *Garden and Forest* 6 (November 29, 1893): 491.

"Prizes for Decorative Art and Needle-Work." *Scribner's Monthly* 21, no. 5 (March 1881): 793–794.

Reed, Henry Hope, and Sophia Duckworth. *Central Park: A History and Guide*. New York: Clarkson N. Potter, 1967.

Repplier, Agnes. "Leisure." *Scribner's Magazine* 14, no. 1 (July 1893): 63–67.

Rinhart, Floyd, and Marion Rinhart. *Summertime: Photographs of Americans at Play, 1850–1900*. New York: Clarkson N. Potter, 1978.

Rochard, M. Jules. "Summer Outings in Europe." *The Chautauquan* 21, no. 6 (September 1895): 709–713.

Routledge, Edmund, ed. *Every Boy's Book: A Complete Encyclopedia of Sports and Amusements*. London and New York: George Routledge and Sons, 1869.

Scourse, Nicolette. *Victorians and Their Flowers*. Portland, Ore.: Timber Press, 1983.

Sherwood, Mrs. M. E. W. *Etiquette: The American Code of Manners*. New York: George Routledge and Sons, 1884.

Smith, Herbert F. *The Popular American Novel, 1865–1920*. Boston: Twayne Publishers, 1980.

"Society of Decorative Art." *Scribner's Monthly* 22, no. 5 (September 1881): 697–709.

Spassky, Natalie. *American Paintings in the Metropolitan Museum of Art*. Edited by Kathleen Luhrs. Vol. II. New York: Metropolitan Museum of Art, 1985.

Speed, John Gilmer. "Golf." *Lippincott's Monthly Magazine* 52 (November 1893): 609–713.

Strayer, O. O'B. "Old Children." *Century Magazine* 25, no. 4 (February 1883): 633.

Sullivan, Mark. *Our Times: The United States, 1900–1925.* Vol. I of *The Turn of the Century.* New York and London: Charles Scribner's Sons, 1927.

Ten Eyck, Henry James. "Educational Value of Summer Resorts." *Century Magazine* 28, no. 5 (September 1884): 796–797.

Thomas, Theodore. "Musical Possibilities in America." *Scribner's Monthly* 21, no. 5 (March 1881): 777–778.

Thompson, D. Dodge. "Julius L. Stewart, a 'Parisian from Philadelphia.'" *The Magazine Antiques* 80, no. 5 (November 1986): 1046–1058.

Trachtenberg, Alan. *The Incorporation of America: Culture and Society in the Gilded Age.* New York: Hill and Wang, 1982.

Upton, George P. "Musical Societies of the United States and Their Representation at the World's Fair." *Scribner's Magazine* 14, no. 1 (July 1893).

Van Rensselaer, M. G. "The Plague of Formal Calls." *Scribner's Monthly* 19, no. 4 (February 1880): 787–788.

Van Scharck, Eugene. "Foils and Fencing." *Lippincott's Monthly Magazine* 51 (January 1893): 107–117.

Veblen, Thorstein. *The Theory of the Leisure Class.* 1899. Reprint. New York: The Modern Library, 1931.

Ward, Mrs. H. O. [Clara Sophia Jessup]. *Sensible Etiquette of the Best Society.* Philadelphia: Porter and Coates, 1878.

Warren, Geoffrey. *A Stitch in Time: Victorian and Edwardian Needlecraft.* New York: Taplinger Publishing Co., 1976.

Weber, Bruce. *Robert Frederick Blum (1857–1903) and His Milieu.* Ph.D. diss., City University of New York, 1985.

"A Wheel Around the Hub." *Scribner's Monthly* 19, no. 4 (February 1880): 481–499.

Williams, Susan. *Savory Suppers, Fashionable Feasts: Dining in Victorian America.* New York: Pantheon Books, 1985.

Wilmerding, John, Earl A. Powers, and Linda Ayres. *An American Perspective: Nineteenth-Century Art from the Collection of Jo Ann and Julian Ganz, Jr.* Exh. cat. Washington, D.C.: National Gallery of Art, 1981.

"Woman and Her Work." *Scribner's Monthly* 21, no. 4 (February 1881): 634.

Yale, Leroy Milton. "Getting Out the Fly-Books." *Scribner's Monthly* 12, no. 1 (July 1892): 27–32.

Young, Andrew McLaren, Margaret MacDonald, Robin Spencer and Hamish Miles. *The Paintings of James McNeill Whistler.* New Haven and London: Yale University Press, 1980.

Young, Dorothy Weir. *The Life and Letters of J. Alden Weir.* New Haven: Yale University Press, 1960.

Index:
Artists and Titles

Photo credits:

Unless otherwise indicated, photographs are credited to the individuals, institutions, or firms owning the works that are reproduced, with the following exceptions: Courtesy of Berry-Hill Galleries, New York: 56; E. Irving Blomstrann: 52; Courtesy of Graham Galleries, New York: 35; Courtesy of Jordan-Volpe Gallery, New York: 129; Courtesy of R. H. Love Galleries, Chicago: 46; Courtesy of and copyright © by The Metropolitan Museum of Art: 31, 32; Richard P. Meyer: 59; Courtesy of Joan Michelman, New York: 61; Otto E. Nelson: 39; Courtesy of and copyright © by Sotheby Parke-Bernet, Inc.: 42.